Learning Calligraphy

Learning Calligraphy

A Book of Lettering, Design, and History

MARGARET SHEPHERD

THORSONS PUBLISHERS LIMITED
Wellingborough, Northamptonshire

First published in Great Britain 1984

Second Impression 1985

Originally published in the United States of America
by Macmillan Publishing Co., Inc., New York

© Margaret Shepherd 1977

British Library Cataloguing in Publication Data

Shepherd, Margaret
 Learning calligraphy.
 1. Calligraphy
 I. Title
 745.6'1 Z43

ISBN 0-7225-1148-5

ISBN 0-7225-0916-2 Pbk

Printed and bound in Great Britain

TABLE OF CONTENTS

"One hesitates between acknowledging one's obligations and implicating one's friends."

H. G. Wells

I owe a debt of gratitude to those tireless and faithful teachers who got me ready to enjoy calligraphy; Dorothy McConnell, who taught me to make things, Velma Rayness, who taught me to draw, Mary Shideler, who taught me to quote, and Mary McNally, who taught me to read prefaces.

THIS BOOK IS DEDICATED TO NORBERTO CHIESA

USING THIS BOOK

Learning Calligraphy is a book about seeing. We live surrounded by letters; they touch our daily lives as much as clothing touches our skin. The more we understand about letters and seeing, the more we can understand about ourselves.

Letters communicate on many levels. This book focuses on three important aspects: lettering them with the broad pen, using them to explore visual design, and seeing them change throughout history. You will be given a short historical background with each chapter, and some very detailed technical advice. Then you should practice copying the Master Sheet, where the letters are grouped in letter families. Extra space is given for you to add alternate letter forms that you come across or that a friend or teacher recommends. When you are familiar with the basic alphabet style, go on to experiment with designing your favorite quotes into whole pages of calligraphy. Each chapter includes historical and contemporary examples that are especially well suited to that alphabet — and warns you about pitfalls as well. Finally, you may want to follow up on suggested readings in other books, to enhance your ability and understanding of a style that interests you particularly.

As you study calligraphy, remember that it should train not only your eye and hand, but your mind, as well.

Your lettering style is your own very personal creation. Use your judgment; the Master sheets, rules, and **suggestions** in this book are intended to guide but not dictate your interpretation of the letter forms of other scribes. When you find a letter, serif, or swash that you prefer, use it. If you like a layout, try it. If at any time a rule interferes with your growth, set it aside temporarily and follow your natural inclination.

Just as the discipline and creativity of learning a musical instrument can add new dimensions to your enjoyment of music, learning calligraphy can open a whole new visual world to your eyes. Not only will you gain appreciation of what goes into making the letters around you, but also you'll begin to find that seeing letters critically leads you to see other things better. As you become more proficient, calligraphy can tie into the related fields of illustration, iconography, linguistics, stone carving, illumination, and history of costume. In short, letters can open up the world around you.

Welcome, then, to the world of calligraphy.

Margaret Shepherd
1 September 1977

SCRIBES & MATERIALS

An Egyptian scribe's materials — pen, pigment, and palette — and the hieroglyph for 'scribe.'

ver since humans began speaking, they have supplemented their sounds with gestures. Writing is really an extension of gesturing –– a way of making a gesture memorable and visible. For a long time people wrote with whatever was handy. They cut notches into sticks, they dug furrows into sand, they poked dents into soft clay, they tied knots in strings for numbers, they painted sketchy pictures on flattened reeds, they wrote on walls. Formal writing evolved out of these stop-gap memory aids.

Carving the painted Roman capitals. From Writing & Illuminating & Lettering, Johnston. Published by Pentalic.

ur cultural ancestors the Romans, whose capital letters we still use today, were active wall writers. With a paint brush or lump of charcoal, they wrote official announcements, advertisements, campaign slogans—as well as gossip, insults, and jokes. ("Everyone writes on walls but me," was among the graffiti found perfectly preserved under the volcanic lava of Pompeii.) The most memorable of the official writings would be made permanent by carving the written letters into a stone surface, where bright Mediterranean sunlight threw them into sharp relief. Thus, Roman capitals originated as a composite paint-brush and stone-chisel style, later to be approximated with pen and ink.

Scribe copying books in medieval scriptorium.
Writing & Illuminating & Lettering. Johnston.
Published by Pentalic.

he scribe of the Middle Ages worked indoors, in the colder, darker climate of northern Europe. Wall writing was not only unnecessary but unsuitable, since there was no strong centralized empire issuing proclamations nor a warm, sunny climate in which to stand and read them. Instead, scribes were concerned with preserving and glorifying the word of God. They wrote on parchment with a quill pen, leaving space for the illuminator to add decorative initial letters, miniature scenes and portraits, and floral borders. These parchment pages were bound between protective covers, in codex, or book, form.

15th century printer. Woodcut by Dürer.

uring the Renaissance, Roman forms of thought and expression were re-discovered, and with them the classical letter style. Almost concurrently, the invention of moveable type and the importation of Oriental paper-making technique caused printing to replace writing in book production. Many lettering styles were taken out of their natural course of development as pen letters, and evolved instead in new directions as type designs. Calligraphy quickly moved out of the mainstream of economic and artistic life; the professional scribe practiced an anachronistic art no longer vital to the everyday workings of society. For three centuries, calligraphy was to live in limbo.

alligraphy was revived 100 years ago in the Arts and Crafts movement in England. While initially traditional materials and tools were reintroduced for calligraphers, the invention of steel nibs and fountain pens made calligraphy accessible to the hobbyist as well.

Today's calligrapher has easy access to facsimiles of history's most beautiful manuscripts; to standardized, inexpensive, reliable materials; to the written or verbal advice of other calligraphers; and to the leisure time to use them all.

n this book we will study the basic letter styles of the last 2000 years by looking at the materials and the historical conditions that shaped them. The letters themselves show you the past through the eyes of the scribe, and knowledge of historical background will enrich your understanding of the letters. When you take up the pen to write the 26 letters, you join distinguished company — the thousands of scribes who have seen the world with a calligrapher's eye.

MATERIALS CHECKLIST

NECESSARY *for alphabet practice*
Ink _____
Pen: wide and narrow nibs * _____
Pencil _____
Eraser _____
Paper _____
Tissues _____
Paper clips _____

OPTIONAL *for designing pieces of calligraphy*
Ruler, straightedge _____
Triangle _____
T-square, drawing board _____
Bristol bond, Strathmore and "3 candlesticks" calligraphy paper
Masking tape _____

OPTIONAL *for decoration*
Watercolor set _____
Brushes _____
Narrow pen, crowquill, Rapidograph pen _____

* Please note~ Osmiroid nibs do not fit Platignum bodies and vice versa.

ou need the following basic materials to work through the lessons in this book: ink, pen, pencil, eraser, and paper.

INK. A bottle of calligraphy fountain pen ink. Do not buy regular India ink; it will clog and ruin any fountain pen. Do not buy plain fountain pen ink; because it is washable, it is too watery to give you a sharp letter.

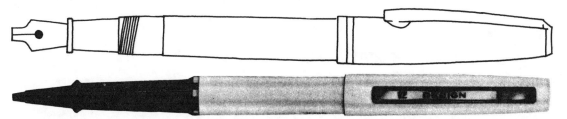

PEN. Calligraphy fountain pen, either Platignum or Osmiroid brand with B-4 and Medium nibs. Or calligraphy felt pens—Eberhard-Faber "Design" No. 492 Chisel Point and "Chiz'l" AD marker (similar to the fountain pen nib widths and even easier to use).

PENCIL. Good quality HB pencil, kept sharp.

ERASER. Art gum is adequate; a Magic Eraser is preferable. Be sure whatever you buy is not gritty.

PAPER. A stack of plain white inexpensive typing paper or plain white bond paper, 8½ × 11 inches.

TISSUES. PAPER CLIPS.

Learning calligraphy is a process of familiarizing yourself with your main tool, the pen. The calligraphy fountain pen is built like a regular fountain pen. Its main parts are ① the nib unit, which screws into ② the reservoir, which screws into ③ the barrel. ④ The cap then screws onto the barrel.

To fill the pen, screw the nib tightly into the reservoir. Hold this unit so that the ink just covers the metal nib. Squeeze and release the metal band around the reservoir 4 or 5 times to force air out and ink in. Wipe off excess ink. If your pen has a lever on the outside of the barrel, screw the reservoir and nib into the barrel before filling. Hold nib in ink and lift lever 4 or 5 times. Wipe off excess ink.

Hand-operated Lever-operated

Ink flows from the reservoir onto the paper by capil-
lary action. You can see the wet ink through the hole
(or holes) about ½ way up the nib. From there it is
drawn down the slit in the point.

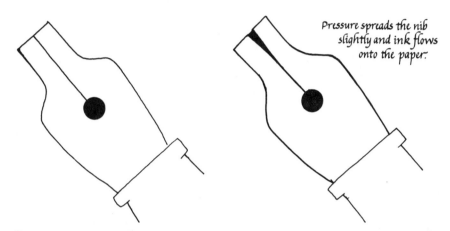

Pressure spreads the nib
slightly and ink flows
onto the paper.

When you write, you press down hard enough to spread
the nib slightly, and the ink in the slit can touch the paper.
If you press too hard, the nib spreads too far apart, and
the ink can not bridge the gap.

To change nibs, remove cap and barrel. Hold reservoir
and nib unit with nib pointing **UP.** Unscrew the first
nib, holding it with a tissue. Screw in the second nib unit
and point the nib and reservoir **DOWN** for a minute to let
the ink seep into the nib.

To clean the pen, squeeze the ink back into the bottle. Un-
screw all four parts of the pen and either soak them in a
bowl of water or rinse them under running water. Shake
and dry **THOROUGHLY.** Some manufacturers recom-
mend cleaning the pen every two weeks.

PROBLEMS:

① Ink all over when you unscrew the cap.

② No ink comes out when you try to write.

③ Ink makes a ragged line on paper.

④ Ink looks transparent and watery on paper.

SOLUTIONS:

Wash cap and dry thoroughly. Screw nib in tightly. Screw cap on lightly. Store pen with nib pointing up to allow for atmospheric pressure change.*

Check to see if reservoir is filled. Wipe nib. Press harder. Press lighter. Take pen apart, rinse, reassemble, and refill. Shake gently.

When you begin stroke, press nib point firmly onto paper with a little side-to-side motion. Be sure both corners of nib touch paper.

Be careful to dry the reservoir thoroughly after rinsing. Use ink specifically labelled "For calligraphy fountain pens." Press harder.

DO NOT try to make darker letters by dipping or filling your fountain pen with India Ink. It will become clogged beyond the possibility of rescue, with the result that you will need a new pen.

If none of these solutions can solve your pen problem, take or send the pen back to where you bought it for exchange.

* Beware of taking a full fountain pen onto an airplane with you or in your baggage. The change in air pressure can make the ink flood out.

Once you have learned at least one of the basic alphabets taught in this book, you will be able to design some original pieces of calligraphy. For this task you will need a few more layout tools; how many depends on which method you prefer for drawing parallel guidelines.

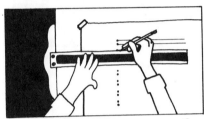

Method 1. Measure with ruler first, then slide **T-SQUARE** along edge of **DRAWING BOARD.**

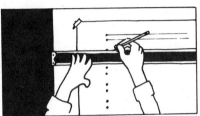

Method 2. Measure with ruler first, then slide **MOVE-ABLE STRAIGHTEDGE** on special drafting board.

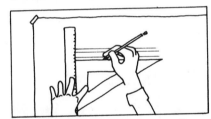

Method 3. Hold ruler firmly on paper and slide **TRIANGLE** to measure distances.

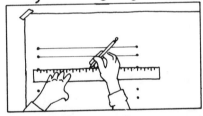

Method 4. Measure distances along both margins and connect dots with ruler.

All these methods apply to calligraphy papers available in art stores. "3 Candlesticks" and Strathmore Manuscript papers are translucent, lightly textured with chain lines, appropriate for prose quotations, poetry, and manuscript books. Strathmore Document paper makes excellent framed presentations and originals for reproduction. Anchor the **PAPER** to your work surface with **MASKING TAPE.** A cork-backed metal **RULER** — inch and metric — is a good investment.

To letter, sit comfortably at a table or desk. Support your weight on your left elbow so your right arm can move freely.

Fasten a piece of paper over the guideline sheet with paperclips. The guidelines should show through the paper. Then letter at least 3 lines of each "practice stroke" shown on the Master sheet, and letter a whole page of each line in the "letter families." Use up a lot of practice paper at this point and don't worry about the mistakes. Concentrate on achieving comfortable arm motion.

If you can't make your arm comfortable without twisting your body, then rotate the book counterclockwise — but only slightly.

Left-handed calligraphers should turn to page 118 in the Appendix.

Lay a sheet of paper over these guide lines and practice a few strokes with the pen to get the ink flowing freely.

The wide calligraphy pen writes like a regular fountain pen except for one important limitation; the ink will not flow well when you push the pen stroke. **PULL** the pen toward you from top to bottom, and from left to right.

Correct Incorrect Correct Incorrect

These small arrows indicate the stroke direction

Pull pen strokes from top to bottom and from left to right. Arrows show the proper **STROKE DIRECTION.**

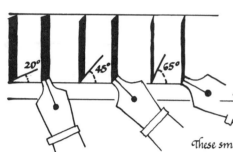

20° 45° 65°

These small pen points indicate the pen angle.

Vary the width of your pen stroke by turning your hand. This changes your **PEN ANGLE.**

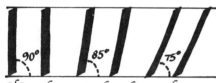

90° 85° 75°

This angle measure shows how much the letter slopes away from true vertical.

Change the angle of the pen stroke in relation to the horizontal guide lines. This changes the **LETTER ANGLE.**

These small numbers tell you the sequence of strokes.

1 1
 2 2

Most letters have a preferred order of strokes. Experiment to find the natural **STROKE SEQUENCE.**

SEEING CALLIGRAPHY

A page from *Didymus Alexandrinus.* Courtesy the Pierpont Morgan Library.

Calligraphy is an art like painting, printmaking, drawing, sculpture, or photography — a way of seeing life, and of communicating what you see. The well-trained, intelligent, inventive calligrapher can explore the world of visual art as thoroughly as the painter. Through letters you can learn about texture, color and line, depth perception, positive and negative space, proportion, and light. You can experiment with a wide range of materials, and the size of your finished piece of calligraphy can be miniature or monumental.

Calligraphy also has much in common with traditional handicrafts and decorative arts — stained glass, gold work, bookbinding, tapestry. People respond to these arts sensually as well as visually, because they are handmade of beautiful materials.

Finally, calligraphy offers an extra dimension — the literary. Your work carries an intellectual message in the content of its text.

The best calligraphy communicates on all three levels, with a striking visual impact, expert craftsmanship on beautiful materials, and a thoughtfully, creatively chosen quotation or text.

The aim of this book is to help you learn the basic letter forms of the broad pen alphabet and then put them into beautiful, interesting, original pieces of calligraphy. Beside the quality of each individual letter, a really good piece of calligraphy communicates on these levels:

Balanced layout

Awkward layout

German word, German letter

German word, Celtic letter

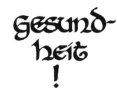

DISRAELI

Thought-provoking quote, graceful letter.

Letter is too refined for the sentiments.

LAYOUT. Is it balanced? Interesting? Original? Does the white space help you see the black areas? Is there variety as well as repetition? Do the colors enhance each other?

CRAFT. Does the letter style harmonize with the layout? Does it suit the historical period, subject, sentiments, or nationality of the text? Are the materials as good as the workmanship?

TEXT. Is the quotation a good one? Well-worded? Of lasting interest? Don't waste your work on a trivial, pompous, or poorly written passage — even your own!

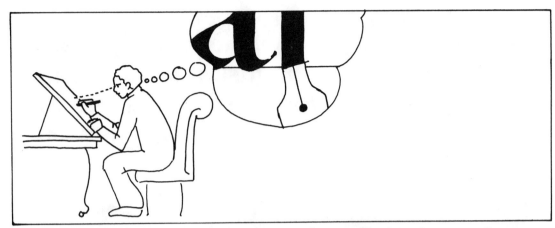

While you work on your calligraphy, letter by letter, keep in mind what your potential viewers will be seeing when they look at it as a whole. You are communicating something to them with the overall layout, the skill and materials, and the selected text — and with the interaction among these three elements. Don't forget that you are about ten inches away when you letter, while your viewers will probably first see your work from a 10-foot distance.

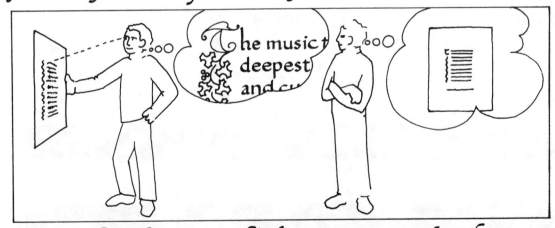

So—see what they see. Hold the paper at arm's length. Tape it on the wall and back away. Squint. Turn it upside-down. Glance at it. Stare at it. Try to **SEE** it for the first time.

As you learn to look carefully at a piece of calligraphy. both from ten inches and from ten feet, you will gradually recognize that **THE WHITE SHAPES ARE JUST AS REAL AS THE BLACK SHAPES.** This critical concept, called **NEGATIVE SPACE,** means that the "empty" space is visually just as important as the inked-in areas.

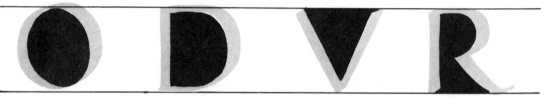

First look at the space **INSIDE THE LETTER**. Watch it take shape as you move the pen .

Second, look at the space **BETWEEN LETTERS.** Learn to judge the area, not the linear distance, between letters and between words.

Third, look at the space **BETWEEN LINES.**

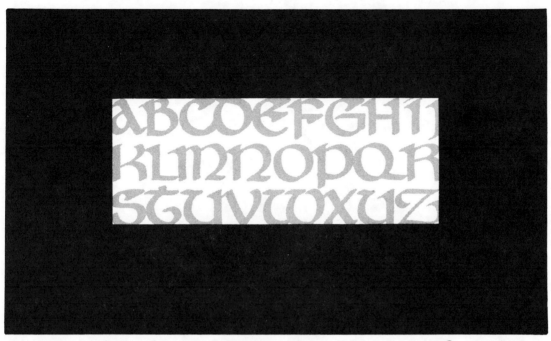

Finally, look at the space between the letters and the edge of the page — **THE MARGINS.** Visualize them in terms of positive and negative space when you plan your piece of calligraphy.

 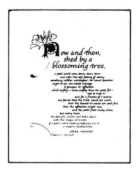

The four pages above illustrate the most common margin configurations. ① Balanced: flush left and right. ② Flush left, ragged right (flush right, ragged left is used much less often). ③ Centered: lines of unequal length. This poem has been laid out to resemble a cross. ④ Free form: ragged left and right.

The different kinds of white space or negative space in a calligraphic page are summarized below.

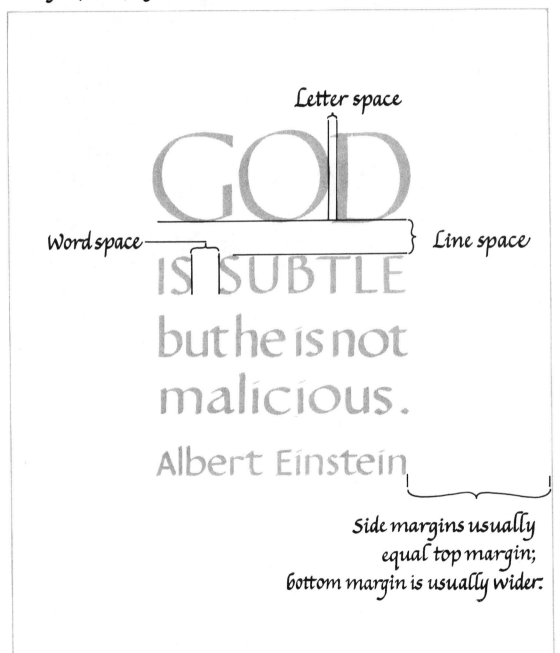

ROMAN

THE ROMAN ALPHABET, LIKE MUCH OF ROMAN CULTURE, HAD ITS ORIGINS IN THE CENTURIES OF COMMERCIAL AND INTELLECTUAL TRADE AMONG DIVERSE MEDI-TERRANEAN COUNTRIES. THE CONCEPT OF ALPHABETIC WRITING AND MANY OF THE SYMBOLS CAME FROM THE ANCIENT PHOENICIANS TO THE GREEKS, AND FROM THEM TO THE ROMANS.

AS ROMAN POWER GREW AND SPREAD, THE ALPHABET BECAME AN ESSEN-TIAL TOOL FOR MAINTAINING THE EMPIRE — FOR PROPAGANDA, MILITARY REPORTS, AND MONU-MENTAL INSCRIPTIONS. IT WAS A VEHICLE FOR LEGIBILITY RATHER THAN SYMBOLISM.

IN ADDITION TO ITS BEAUTY, SIMPLICITY, AND CLARITY, THE ROMAN LETTER SHOWED FROM ITS VERY BEGINNINGS THE QUALITY OF RESILIENCE. IT IS EASY TO WRITE AND TO READ IN MANY DIFFERENT MEDIA, IN MANY DIFFERENT SIZES; IT COMMUNICATES CLEARLY WHETHER WRITTEN WITH A SMALL PEN OR CARVED IN STONE LETTERS FIVE FEET TALL.

The Roman letter demands strict attention to the proportions created by the letter strokes. Always bear in mind the relation between the **HEIGHT** and the **WIDTH** of each letter.

O, C, G, Q, and D are exactly as wide as they are tall; they can be fit into a square and just touch all four sides.

E, F, L, B, P, R, and S are half as wide as they are tall.

H, T, U, K, N, A, V, J, X, Y, and Z are about three-quarters as wide as they are tall.

M and W are about 25% wider than they are tall; they extend beyond a square.

These proportions hold true no matter what size the letters are. They are essential to the character of the formal Roman capital.

Although Roman letters are a monument to proportion, they deceive the eye in subtle ways.

H E B S X

When you cross the H, take care to place it slightly ABOVE the exact geometrical middle. E, B, S, and X also have a smaller top than bottom.

F P R A Y

Other letters cross BELOW the exact center. F, P, R, A, and Y have a smaller bottom than top.

FPR EB LD
AV AW VM

Notice the KINSHIP between letters. F, P, and R are identical on the left-hand third of the letter. E and B, L and D similarly share the same backs. A is an inverted V plus the cross-stroke; both are contained in the midsections of M and W. You can find and emphasize other family resemblances as you learn the letters.

Roman capitals demand special attention to the pen angle. You CANNOT do the whole alphabet with the same pen angle. Some letters are done with the pen angle of 20°; other letters are done with the pen angle of 45°.

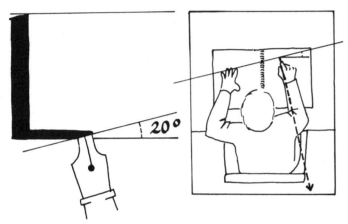

To hold the pen at 20°, keep your elbow near your body. The end of the pen should point toward your right shoulder.

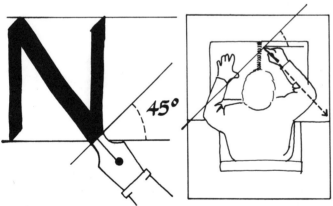

To hold the pen at 45°, move your elbow out away from your body. The end of the pen should point into space to the right of your body.

The letters I, L, E, F, D, B, P, R, O, C, G, Q, H, T, U, K, and J are written with the pen held at a 20° angle. The letters N, V, X, W, and M are written with the pen held at a 45° angle.

These two pen angles will give you the correct width of stroke
for nearly all the Roman alphabet; only four more letters
need any special treatment: A. Y, Z, and S.

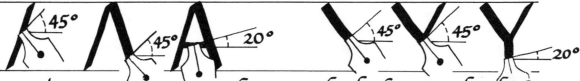

A and Y are exceptions to the general rule that you should keep
the pen at the same angle for all strokes of a letter. The first
two strokes of A are 45° strokes; the crossbar is done at 20°.
Similarly, the first two strokes of Y are at 45°; the stem is at 20°.

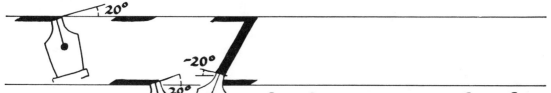

Z necessitates a new pen angle. The two horizontal strokes are
made first at 20°. Then connect them diagonally, making a
thick stroke by turning your hand to a backward 20° pen angle.

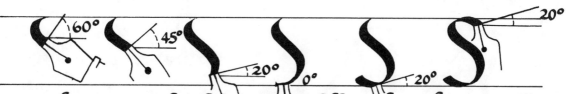

To make S properly, the pen must follow along the center curve.
The pen angle will always be perpendicular to the curve. The
second and third strokes are at 20°.
Careful attention to these details will keep your Roman capitals
pure and authentic.

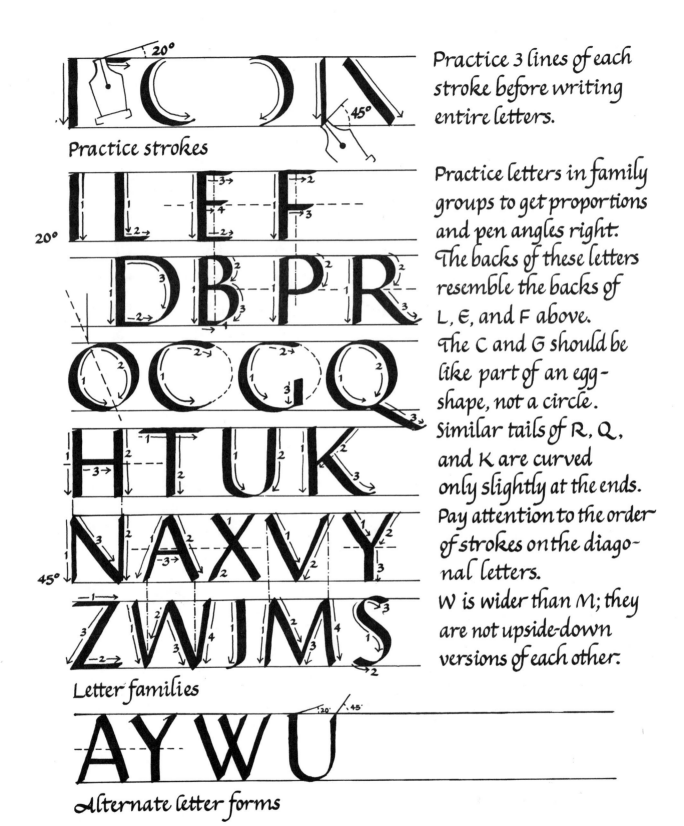

Practice strokes

20°

Letter families

45°

AYWU

Alternate letter forms

Practice 3 lines of each stroke before writing entire letters.

Practice letters in family groups to get proportions and pen angles right. The backs of these letters resemble the backs of L, E, and F above. The C and G should be like part of an egg-shape, not a circle. Similar tails of R, Q, and K are curved only slightly at the ends. Pay attention to the order of strokes on the diagonal letters. W is wider than M; they are not upside-down versions of each other.

Do not write directly on this sheet.
Lay a piece of paper over it so that
the guidelines show through faintly.

Pen angles

20° 45°

B4 B4

Letter | angle

Proportion (see page 32)

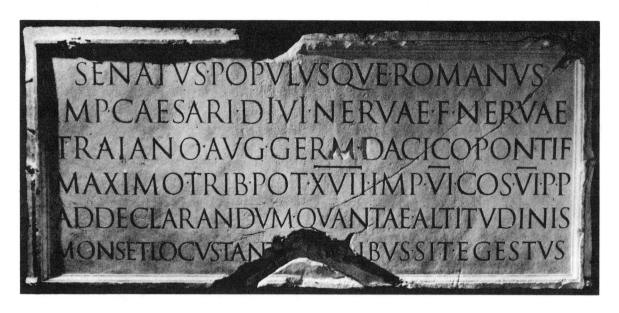

The Trajan Inscription. 113 A.D. Photo courtesy of R. R. Donnelley & Sons Company.

The Trajan inscription shown above is considered one of the best models for the Roman letter. As a beginning calligrapher, after your initial practice with the alphabet master sheets provided in this book, you should use original sources as models to copy. Learn to look at them graphically. How have the calligraphers of centuries ago solved the same design problems that face you? What materials have they chosen? What size is the work? How have they handled the spaces between the letters? between the words? between the lines? Are the lines the same length, and the letters the same height?

F. Poppl. Courtesy Victoria & Albert Museum.

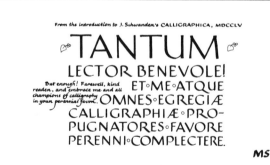

Here are some suggested layouts for designing your own pieces of calligraphy with Roman letters. The formal Roman capital is extremely readable in short passages; you may, however, find that longer passages seem uninviting to modern eyes. Since punctuation was as yet unknown in classical Rome, you may enjoy breaking sentences with a small pen-stroke or an orna-ment, as they frequently did. Roman capitals also make elegant monograms, bookplates, titles, and letterheads.

LET US
NOT BE TOO
PARTICULAR.
IT IS BETTER
TO HAVE OLD
SECONDHAND
DIAMONDS
THAN NONE
AT ALL. MARK
TWAIN

MS

Margaret Shepherd

DANFORTH ⌂ MUSEUM
SUNDAY, MAY 1, 6:00-8:00 P.M.
THIS INVITATION ADMITS TWO
(PLEASE PRESENT AT DOOR) MS

THAT WHICH
DOES NOT
DESTROY ME,
MAKES ME
STRONGER

NIETZSCHE

MS

STONECUTTERS
FIGHTING TIME WITH MARBLE

YOU FOREDEFEATED CHALLENGERS OF OBLIVION; EAT
CYNICAL EARNINGS, KNOWING ROCK SPLITS, RECORDS
FALL DOWN, THE SQUARE-LIMBED ROMAN LETTERS
SCALE IN THE THAWS, WEAR IN THE RAIN. THE POET
AS WELL BUILDS HIS MONUMENT MOCKINGLY, FOR
MAN WILL BE BLOTTED OUT, THE BLITHE
EARTH DIE, THE BRAVE SUN DIE BLIND,
HIS HEART BLACKENING. YET
STONES HAVE STOOD FOR A
THOUSAND YEARS & PAINED
THOUGHTS FOUND THE
HONEY OF PEACE
IN OLD
POEMS

TO THE STONECUTTERS ⌐ ROBINSON JEFFERS MS

When you have practiced the Roman capitals enough to know the basic proportions and understand how the letter families relate to each other, you can start to pay attention to the ends of the strokes — the serifs. Originally, Roman stonecutters finished off the ends of each chiselled letter stroke with a small tapering wedge. Calligraphers imitated this effect with a variety of pen-and-ink serifs.

There are two main approaches to adding a serif to the basic Roman capital letter.

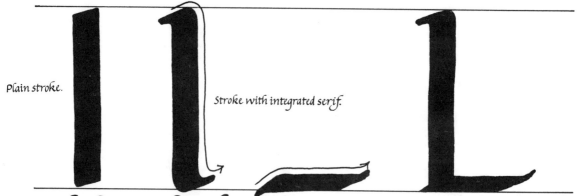

Plain stroke.

Stroke with integrated serif.

In the first method, the serif is made as an integral part of the stroke, in one motion.

ABCDEFGHIJ
KLMNOPQRS
TUVWXYZ

① Serifs done with each stroke

The second kind of serif is a separate stroke added to the top and
bottom of all vertical strokes, in a separate motion.

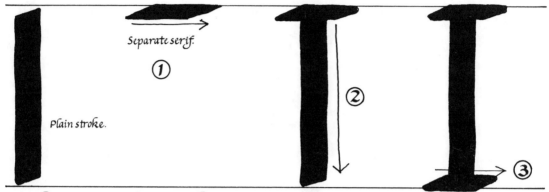

Separate serif.

① Plain stroke.

②

③

Do the top serif first, then the stroke, then the bottom serif.
Turn the pen back to the usual 20° pen angle even for 45°
letters so that the serifs are consistent from letter to letter.

ABCDEFGHIJ
KLMNOPQRS
TUVWXYZ

② Serifs
added with
each stroke

While both serifs are acceptable, the first is simpler, cleaner-
looking, and more graceful. It interferes less with your rhythm
of lettering. The second serif gives the letters more weight
and emphasis; but it also tends to look awkward and heavy,
and slows you down. You should familiarize yourself with
both, and then practice the one that best suits your style.

"Alphabet follows empire." As the power of Rome grew, the
Roman letter reached the peak of its development. With the
decline of centralized power, however, the beauty of the Roman
letter was submerged into less sophisticated local writing styles
on the empire's perimeter – the Quadrata and the Rustica. They
look like what you might produce by copying a third-hand
copy of Roman capitals if no one had pointed out to you the
importance of changing the pen angle and of making some
letters wider than others. Quadrata letters tend all to be
wide, with a 20° or 15° pen angle for most letters; Rustica
letters tend all to be narrow, with a 70° or 80° pen angle.

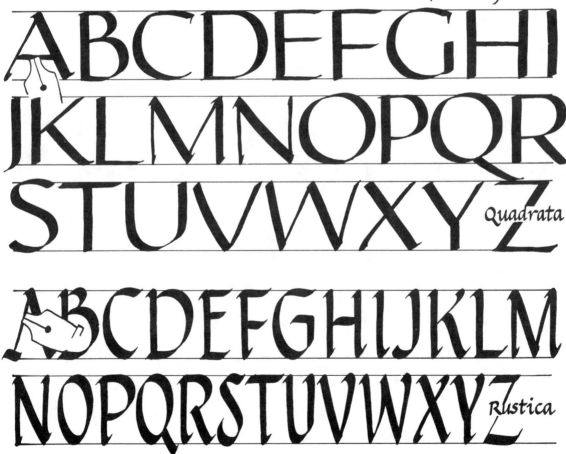

Quadrata

Rustica

Practice these transitional Roman styles to understand them historically. While neither is a major form in itself, they provide stepping stones to the next major developments, Celtic and Gothic.

I·AM·A·PART·OF·ALL·THAT·I·HAVE·MET;
 YET·ALL·EXPERIENCE·IS·AN·ARCH·WHERETHRØ
GLEAMS·THAT·UNTRAVELL'D·WORLD, WHOSE·MARGIN·FADES
 FOREVER·AND·FOREVER·WHEN·I·MOVE/
HOW·DULL·IT·IS·TO·PAUSE, TO·MAKE·AN·END,
 TO·RUST·UNBURNISH'D, NOT·TO·SHINE·IN·USE!
AS·THO'·TO·BREATHE·WERE·LIFE/ LIFE·PILED·ON·LIFE
 WERE·ALL·TOO·LITTLE, AND·OF·ONE·TO·ME
LITTLE·REMAINS; BUT·EVERY·HOUR·IS·SAVED
 FROM·THAT·ETERNAL·SILENCE, SOMETHING·MORE,
A·BRINGER·OF·NEW·THINGS; AND·VILE·IT·WERE,
 FOR·SOME·THREE·SUNS·TO·STORE·AND·HOARD·MYSELF,
AND·THIS·GRAY·SPIRIT·YEARNING·IN·DESIRE
 TO·FOLLOW·KNOWLEDGE·LIKE·A·SINKING·STAR
BEYOND·THE·UTMOST·BOUND·OF·HUMAN·THOUGHT/

FROM·ULYSSES·BY·ALFRED·LORD·TENNYSON

LETTER·FORMS·BASED·ON·THOSE·USED·IN·A·POEM·ON·THE·BATTLE·OF·ACTIUM
ONE·OF·THE·DECISIVE·BATTLES·OF·THE·WORLD/ AD, 79

Ray F. DaBoll

COMPARISONS ARE ODOUROUS.

SHAKESPEARE

MS

Final note: the symbol at the left edge of your guide line sheet shows you how to figure the height of your letter in relation to the width of your pen. It is made by turning the pen parallel to the writing line for a pen angle of 90°, and then making a stack of short pen strokes, staggering them so you can line up the corners accurately. If you check the Roman alphabet, you will find that the ratio of letter height to pen width is 8 to 1.

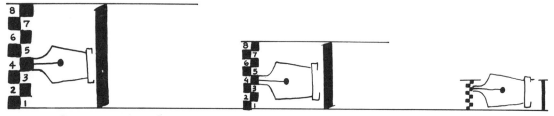

To achieve the same ratio whatever the pen size, just turn the pen sideways and make the stack of 8 squares.

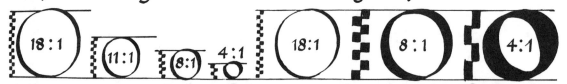

For a heavier or lighter letter, vary the letter height or the pen width to change the ratio.

ROMAN LETTERS: RECOMMENDED READING
Oscar Ogg, The Twenty-six Letters. T. Y. Crowell & Co.
Albrecht Dürer, Of the Just Shaping of Letters. Dover.

CELTIC
_{pronounce this hard 'c'}

FTER THE FALL OF the ROMAN EMPIRE,

OTHER EUROPEAN COUNTRIES ALSO USED THE ROMAN LETTER, ADJUSTING IT TO SUIT LOCAL SOCIAL NEEDS AND DECORATIVE TRADITIONS. WHEN St. PATRICK INTRODUCED CHRISTIANITY INTO IRELAND IN THE FIFTH CENTURY, HE BROUGHT WITH HIM TEXTS DONE IN QUADRATA, THE ROUNDED, SIMPLIFIED ROMAN CAPITALS. THE CELTS COPIED THESE SCRIPTURES, ADDING THEIR OWN INDIGENOUS STYLE OF DECORATION AND MAKING THE LETTERS EVEN MORE ROUNDED TO HARMONIZE WITH CELTIC SPIRAL AND CIRCLE MOTIFS. BY 800 A.D., THIS STYLE HAD REACHED AN ASTONISHING LEVEL OF CREATIVITY, EXEMPLIFIED IN THE BEAUTIFUL BOOK OF KELLS.

AT THE SAME TIME, CELTIC SCRIBES DREW ON A SECOND LOCAL GRAPHIC TRADITION — RUNES, THE PRE-ROMAN NATIVE LETTERS OF THE BRITISH ISLES, SCANDINAVIA, AND NORTHERN EUROPE. BECAUSE THEY ORIGINATED IN WOOD, STONE, AND METAL CARVING, RUNES WERE MADE OF STRAIGHT LINES. IMPOSING THIS RUNIC OUTLINE ON THE ROMAN LETTER, THE CELTS MADE A NEW ALPHABET, EXTREMELY USEFUL FOR ABSTRACT ORNAMENT.

The Celtic letter is much heavier than the Roman letter;
that is, it has a letter-height to pen-width ratio of about
5 to 1 rather than 8 to 1. This fact, plus the flatter pen angle
of about 15°, makes a rounder, fatter alphabet than the Roman.

L L L L L L L I I

As L looks more like I,
I develops its own
distinguishing mark.

Several different design elements evolved simultaneously
in the Celtic alphabet. In some letters, such as L, the
thin stroke became so unimportant visually that it could be
shortened or omitted if the reader was given another clue to the
letter's identity. So the initial stroke was lengthened, and the I,
which it now somewhat resembled, was given an identifying dot.

E E E E E

Strokes run together and
letters get rounder as
scribes work faster and
copy each other's shortcuts.

A A A A A A A A A

H H H h h h h h h

In other letters, such as D, T, E, F, and A, the demands of speed
and the round decorative style made the straight strokes tend
toward rounded forms. Many letters, including S, were gathered
into the O-family group, while letters formerly straight on both
sides — H, N, U, M, and W — developed a bulging curve on one side.

B B B B b b b

G G G G G g g

Further changes occurred when letters like B, E, G, and R
were subjected to streamlining; extra strokes, originally part of
the Roman letter, shrivelled and disappeared. Other strokes, often
previously decorative or subordinate, took over the function of
identifying the letter.

D D D D d d d

Q Q Q Q q q q

F F F F f f f

Finally, small **ASCENDERS** and **DESCENDERS** began to
appear. Sometimes, as with D and B, P and Q, L and J, the
extra length above or below the main body of the letter is all that
differentiated pairs of letters from each other. Other letters
grew ascenders and descenders to stay in visual harmony
with the new forms.

Pay very careful attention to the serif of the Celtic letter. The letters appear in so many variant forms that you really <u>need</u> the distinctive serif to pull them all together.

The first serif is the wedge-shaped buildup on top of most vertical strokes. It is easy to make if you notice that it is built up of two overlapping strokes, one curved, one straight. You may make them in either order, as long as they are accurately superimposed on each other.

The second serif is built up, similarly, of two overlapping strokes. It is added to the top curve of open-sided round letters.

The third serif — a modern addition — is a kind of foot added to the otherwise weak, thin curve of an open-bottom letter.

Unlike Roman, Celtic is a very individual style. There are so many different versions of each letter to choose from that each scribe's 26 selections are bound to be distinctive. In addition, the letters themselves are very elastic; a Celtic letter can grow or shrink to fit the space it finds itself in.

These are only a few of the M's to be found in the Book of Kells.

These different E's appear on one page of the Book of Kells.

A sampling of some of the S's appearing in Celtic manuscripts.

These A's are collected from several manuscipts.

You can see from these examples that the worksheet on page 38 should serve only as the most elementary jumping-off point for your exploration of Celtic letters. Once you have mastered the basic style of the alphabet, experiment freely and always be looking for new letters.

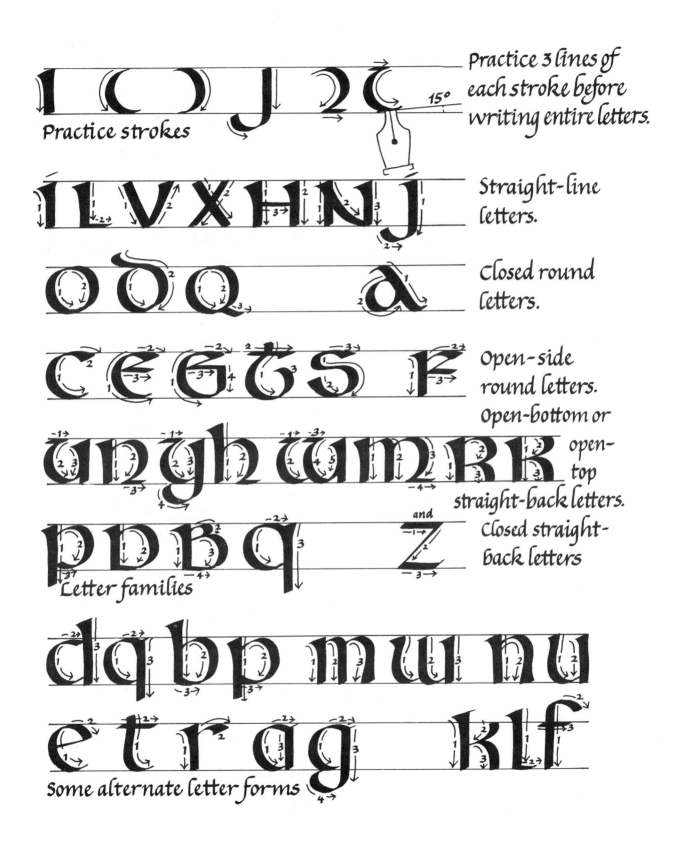

Practice 3 lines of each stroke before writing entire letters.

15°

Practice strokes

Straight-line letters.

Closed round letters.

Open-side round letters.
Open-bottom or open-top straight-back letters.

Closed straight-back letters

Letter families

Some alternate letter forms

Do not write directly on this sheet. Lay a piece of paper over it so that the guidelines show through faintly.

Pen angle

15°

Letter angle

B4

Proportion

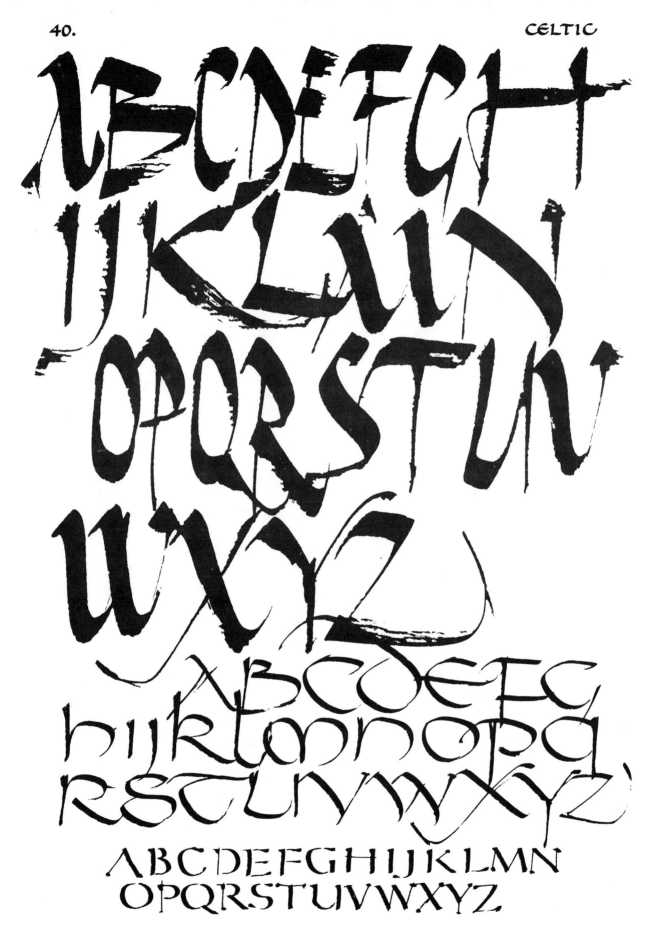

David Howells

Personally developed alphabets stemming from Rustic, Uncial, and Quadrata.

Celtic calligraphy is, above all else, full of fun. A letter or a word can be manipulated to look like an animal, a spiral, or a richly patterned Oriental rug. The scribe's choice of letter forms is individual, quirky, expressive; the alphabet seems to smile. It is never somber. It suits both short and long prose quotes — generally optimistic, light-hearted ones. (Leave sobriety and dignity to be expressed in Roman capitals.) It does not particularly enhance conventional poetry, and tends to look incongruous if used with a quote in any language other than Gaelic or English. The plasticity of the letters and the reader's tolerance of unusual spacing gives the scribe an almost magical ability to make uneven lines come out the same length.

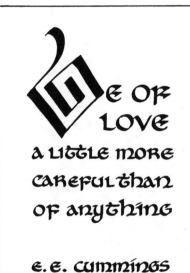

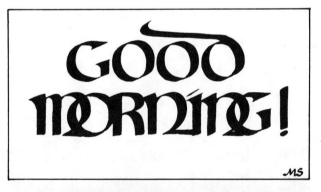

Celtic is the best alphabet for experiments with unconventional spacing.

With Celtic calligraphy the scribe has a great deal of freedom in letter spacing and line spacing. While Roman letters need "air" around them for readability, Celtic letters adapt well to tight spacing or even overlapping.

STANDARD

Standard spacing surrounds each letter with "air" or white space to enhance legibility.

Tight spacing

Tight spacing pushes the letters together until they touch. There are three main kinds of touches, corresponding to the three main letter spaces shown on page 16 ; ① between two straight strokes, ② between two curved strokes, and ③ between a straight stroke and a curved stroke. Notice how the Celtic serif keeps the two straight strokes from truly touching, however. When a touch causes a possible ambiguity by making two letters combine to resemble a third, be sure to give your reader some clues. The C I touch, above, ④ , might be misinterpreted as U if the identifying stroke were omitted.

OVERLAPPING

Overlapping spacing allows two curves to be superimposed, creating a new white space trapped within.

Letter spacing, line spacing, and margin size offer a wide range of spatial possibilities from light and open to heavy and compact. Your choice will depend on the overall balance of light and dark that you want, and, to some degree, the mood of the quotation you have chosen.

AS FOR SOCIAL PLEASURES,
ONE OF THE HIGHEST ENJOY-
MENTS IS AGREEABLE COM-
PANY AND GOOD CONVERSA-
TION; AND 1 ESPECIALLY LIKE
MEN, WOMEN, AND CHILDREN.

william Lyons Phelps

Open line-spacing (with standard letter-spacing)

THE CAPACITY
FOR CORRECT
CLASSIFICATION
IS THE ESSENCE of
HUMAN WISDOM

ARISTOTLE

Compact line-spacing (with tight letter-spacing)

You may occasionally want to try the squared-off Runic capitals—one or two, or a line, per page. You can get your designs by research, by looking at facsimiles of Celtic manuscripts and copying the letters that appeal to you. Or you can invent your own, by looking at the manuscripts and then trying to follow the same creative processes that the original scribes used in designing their capital letters.

To make your own Runic capitals, choose a rounded Celtic letter and reduce all the curves to straight lines. Retain the wedge-shaped serif, make the whole letter proportionately taller and narrower, and keep all strokes the same width.

Don't be put off by the abstract, unreadable quality of runes. If you use them very sparingly — one large letter or one familiar word to a page — the context will help the reader understand.

CELTIC LETTERS: RECOMMENDED READING

George Bain, Celtic Art, The Methods of Construction. Dover. The Book of Kells. Facsimile edition in color, with commentary. Alfred A. Knopf.

Familiarity with these two books is absolutely essential if you are interested in exploring Celtic calligraphy. They are a joy to read and work with.

gothic

he Gothic letter is a category that encompasses dozens of similar letter styles popular during the Middle Ages. The important characteristic they have in common is the prevailing spirit of the era—uniformity. Within each local style, all the letters strongly resemble each other; in addition, many of the white spaces both inside and between the letters are nearly identical. This makes the Gothic letter less legible than the Roman capital and less expressive than the Celtic letter, but it means that the scribe can work faster and compress more information into the limited space on a parchment page.

The Gothic letter in its most typical form is composed almost exclusively of thick, straight strokes, a natural outgrowth of the Roman Rustica, the indigenous runes of Northern Europe, and the romanized runic capitals of Celtic manuscripts. The effect of these uniform strokes in a mass on the page is of a smooth overall texture; hence the common origins of our words TEXT, TEXTURE, and TEXTILE, from the Latin root for WEAVING.

Gothic persists today primarily for ceremonial use: diplomas, mastheads, and presentations.

Gothic letters are a combination of straight strokes and square serifs, all made at a constant 45° pen angle. Turn the pen until the flat end of the pen nib makes an imaginary diagonal line across an imaginary square. ①

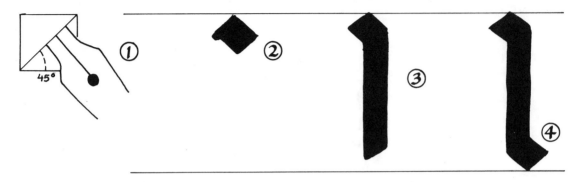

Make a short stroke, as long as it is wide. ② All four sides should be the same length. This square, balanced on its corner, is your serif. Pause; then, without lifting the pen or changing the pen angle, ③ change stroke direction. Pause at the bottom of the stroke, ④ make another square serif, and lift the pen.

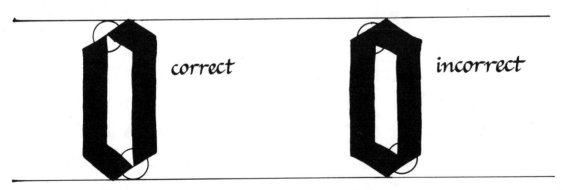

When you join together these strokes and serifs, be extremely careful to make them touch but not overlap.

To gain accurate control over the Gothic letter, you must learn to see two shapes at once—four-sided inside and six-sided outside.

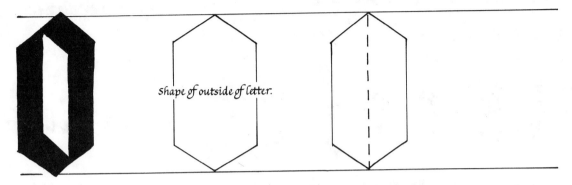

Shape of outside of letter.

First, look at the outline of the letter. It has six sides. It is balanced and symmetrical; you could fold it down the middle. At first glance, you might assume it was made of six strokes.

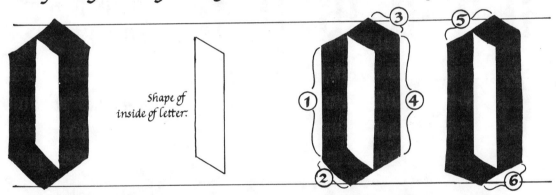

Shape of inside of letter.

Now, however, look at the inside space of the letter. It has four sides. This letter consists of two serifs and two strokes; the illusion of two more edges is created by lining up the edges of the broad strokes.

It is absolutely essential to watch both the inside and the outside shapes of the Gothic letter take form as you letter, and to practice making the joined strokes barely touch at their corners. Accuracy is important.

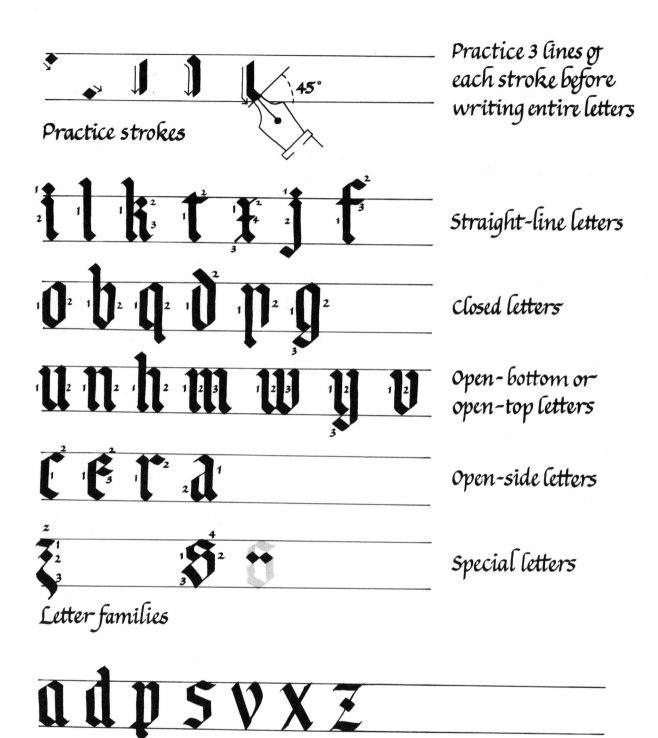

Practice 3 lines of each stroke before writing entire letters

Practice strokes

Straight-line letters

Closed letters

Open-bottom or open-top letters

Open-side letters

Special letters

Letter families

Some alternate letter forms

*Do not write directly on this sheet.
Lay a piece of paper over it so that
the guidelines show through faintly.*

Pen angle 45°

Letter angle

Proportion

There are four levels of uniformity in the Gothic page. To achieve an even overall texture you need to control them all as you letter.

Correct Incorrect

First, each vertical stroke must be parallel to all the others. Do not let any stroke lean at a different angle; it will distract the eye immediately.

Correct Incorrect

Second, the white space inside each letter should be identical in width to the interior space of all the others.

Practice keeping this interior width equal to the width of the stroke itself; the discipline will make your letterspacing easier to control later on.

Correct Incorrect

Third, and most important, the spaces between the letters must be equal to the spaces inside the letters. A simple visual way to remember this rule is to picture the letters without their tops and bottoms; many letter groups will resemble a row of alternating identical black and white stripes. (C, E, R, A, K, F, T, and S will, of course, necessitate a break in the striped uniformity.)

Correct Incorrect

Finally, although some Gothic letters have ascenders and descenders, keep them short. They should hug close to the letter body, providing only minimal distraction.

When you design calligraphy with the Gothic letter, you will need to keep in mind its great strengths and its equally great weaknesses. It gives an overwhelming medieval, religious, earnest flavor to any quote... a flavor that can clash with a quote that is light, contemporary, and ironic. At the same time, the Gothic letter is so abstract that it lends itself readily to intellectual quotes and experimental, unconventional layouts.

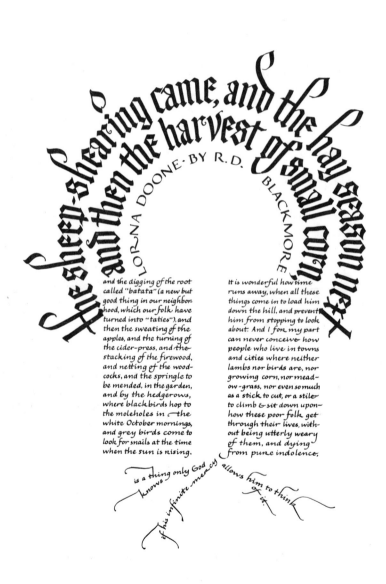

the sheep-shearing came, and then the harvest of small corn, and the hay season next · LORNA DOONE · BY R.D. BLACKMORE

and the digging of the root called "batata" (a new but good thing in our neighborhood, which our folk have turned into "taties"), and then the sweating of the apples, and the turning of the cider-press, and the stacking of the firewood, and netting of the woodcocks, and the springle to be mended, in the garden, and by the hedgerows, where blackbirds hop to the moleholes in the white October mornings, and grey birds come to look for snails at the time when the sun is rising.

It is wonderful how time runs away, when all these things come in to load him down the hill, and prevent him from stopping to look about. And I for my part can never conceive how people who live in towns and cities where neither lambs nor birds are, nor growing corn, nor meadow-grass, nor even so much as a stick to cut, or a stile to climb & sit down upon — how these poor folk get through their lives, without being utterly weary of them, and dying from pure indolence;

is a thing only God knows of his infinite mercy allows him to think of it.

MS

The Gothic letter stimulates and challenges the calligrapher who works with, rather than against, its outstanding features— it is strong, angular, and vertical, and it is difficult to read. If you want to make a Gothic quote easy to read, it is best to face facts and choose a short, familiar one. Space it carefully. When you letter Gothic on an enlarged scale, as in the left hand example above, you will reveal how good your lettering technique is. Be particularly accurate. Plan your letter-spacing thoroughly in pencil and execute the strokes with precision.

The strong vertical strokes of Gothic, which can get repetitive, static, and boxy in some layouts, take on fresh visual impact in a circular layout. The vertical strokes radiate outward like spokes. In this instance, you can emphasize and extend the ascenders and descenders to ornament the outlines of the circle.

To explore further the Gothic form, keep the letters the same width but change the height.

7:1 abcdefghi jklm

6:1 abcdefghi jklm

5:1 abcdefghi jklm

4:1 abcdefghi jklm

3:1 abcdefghi jklm

GOTHIC LETTERS: RECOMMENDED READING

Dürer, _Of the Just Shaping of Letters._ Dover.
 The final two pages deal very technically with Gothic.
Nesbitt, Alexander, _The History and Technique of Lettering._ Dover.
 Shows and discusses many related kinds of Gothic letter.

Gothic Capitals

APITALS DURING the MIDDLE AGES Were Part Letter, Part Ornament. Because so Few People Could Read, and because Gothic Letters Were so Difficult to Read anyway, the Pictures That Decorated the Manuscripts Took on Great Importance. The Small Letter Performed the Function Filled by Microfilm Today~Information Storage in Minimum Space. The Large Letter Communicated on a Pictorial Level, Much Like Present Day Tabloids and Billboards. The Letter-Identity of the Capital Eventually Became so Much Subordinated to this Decorative Function that, Often, A Large Letter Served as Little More Than a Frame for the Detailed Stories, Patterns, and Ornaments It Contained.

There Are Two Techniques for Making Capital Letters: Pen-Lettered and Drawn-and-Filled-In. Both Are Derived in Form From Roman Capitals, via the Rounded Celtic Letters Brought From Ireland to Northern Europe by 7th Century Christian Missionaries. The Same Two Techniques Were Used by Illuminators in Adding Decoration to the Lettered Manuscript Page.

Pen-lettered capitals should be 1¼ times the height of the small letters they accompany, or about 6 – 7 pen widths high.

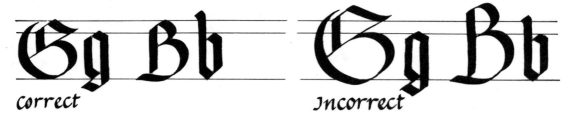

correct Incorrect

If they are too tall, they will also be proportionately too wide, and overpower the text.

The pen capitals start with a basic shape that is very closely related to the Roman or Celtic letter; often the only difference is a kind of stylized non-joining of the strokes. Then embellishments are added on to the basic forms, depending on letter family groupings. Many of these decorative strokes require a different pen angle or an advanced pen technique.

The simplest embellishment is doubling one main stroke.

Thin straight lines sometimes take the place of, or are added next to, straight strokes in the letter. These require either a 90° or 0° pen angle, a steady hand, and a good eye for the vertical.

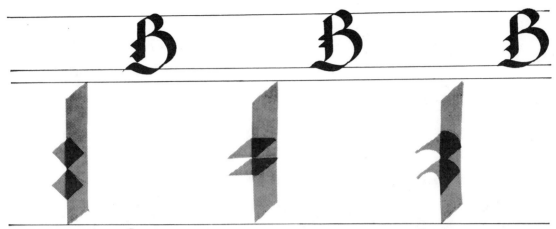

Straight-backed letters can be decorated on the outside edge with the Gothic diagonal square serifs, flat strokes, or curved strokes. Take a close look at how these three decorations relate to the back of the letter. The square overlaps diagonally; the flat strokes intersect exactly; and the curved strokes seem to grow like branches springing from a stem. Choose the style you like and use it on all straight-backed letters.

The banner can be added to almost any letter, floating un-attached or connected to a thin line. To make the small tendril at the left end, go back after you make the main stroke and pull out a little of the still-wet ink with the corner of the pen point. Or simply use a smaller pen.

Practice 3 lines of each stroke before writing entire letters.

Practice strokes

straight-back letters

Round letters

Special letters

Letter families *Shaded strokes are nearly identical*

Some alternate forms.

Do not write directly on this sheet.
Lay a piece of paper over it so that
the guidelines show through faintly.

Pen angle 45°

Letter angle

B4

Proportion

Drawn-and-filled-in capitals are done with a small paint brush or a narrow pen. The outline can then be filled in with ink, paint, or gold.

The most important thing to watch is the symmetry of the drawn capital. First, be sure to give yourself a pencil guide-line to center and balance the slight inward curvature of the vertical stroke. (Erase the pencil line later.)

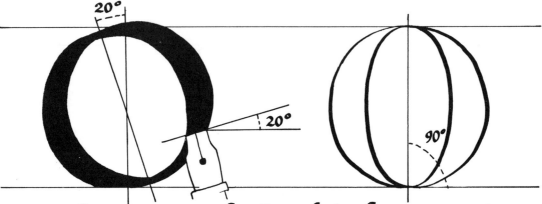

Second, this symmetry should include the rounded letters as well. While a pen-lettered capital will have an axis of symmetry corresponding to the pen angle, the drawn-and-filled-in capital should have a perfectly vertical, 90° axis of symmetry.

Once you have drawn the outlines of the basic letter shape, you will need to finish off the ends of the strokes with serifs.

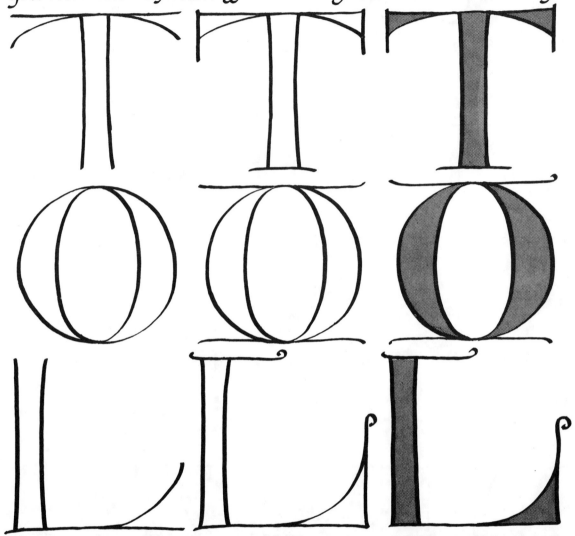

These serifs can extend the full width or height of the letter, and are such a prominent feature of the drawn-and-filled-in capital that they are often found on letters like O that don't really need them at all! Furthermore, the extended serifs themselves can be finished off with other, smaller serifs.

Practice strokes

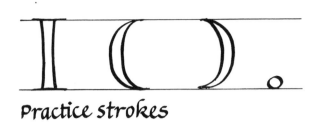

Practice strokes

ILFDBPR

HTUKJ

Straight-back letters

OQCEGCS

Rounded letters

AVNXYZW

Letter families Diagonal letters

AMRCN

Some alternate forms

Pen angle

10°

Letter angle

MEDIUM

Background too large

Background too small

Background proportioned correctly

A drawn-and-filled-in letter looks best when it is anchored to a background, and when the background is neither too large nor too small in relation to the letter. Keep the letter plain; decoration belongs in the background.

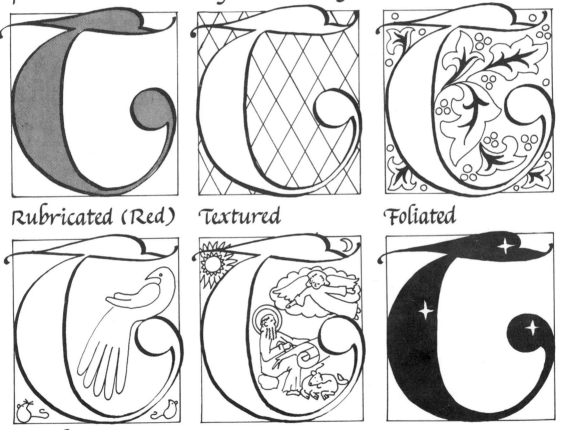

Rubricated (Red) Textured Foliated

Inhabited Historiated Illuminated (Gold)

Decorative treatment of the background has changed and elaborated over the years.

From a 13th century Bible. Courtesy Pierpont Morgan Library.

Gothic capitals have the most impact when used one at a time, or, if small, two or three in a page of text. A drawn-and-filled-in capital, particularly, is a prima donna—it will not be happy with too much competition! (Don't even bother to write out whole words or lines in ALL CAPITALS; they will almost always clash with each other.) To highlight the one large capital, subdue the text lettering, keep the letter-spacing and line-spacing tight, and leave a lot of white space in the margins.

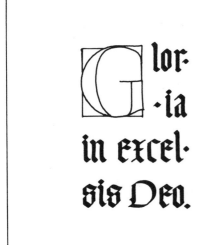

The quotations above show two approaches to designing a page with one large capital. In the first, it conforms to the left-hand and top margins, and is treated visually as part of the block of text. In the second design, the capital sits completely outside the block of text, and is treated as a separate entity.

In each of these designs there is a great deal of white space.
In Gothic calligraphy this space can be left blank, or filled in
with decoration or marginal commentary. In either case,
treat space as part of the graphic design, not as an afterthought.
In the first example, equal margins all around seem most
suited to an all around border treatment. In the second,
the asymmetrical (off-center) design has left a space at
the left which can be filled with one strip of border to
balance the layout.

These gray areas suggest how you can visualize the layout
of your page—or any other scribe's work—before you
pay attention to specific ingredients. Learn to be aware
of the abstract visual effect of calligraphy at the same time
you are immersed in the historical background and
details of technique.

Since this book is primarily about calligraphy, not drawing, we will deal with decoration only briefly in connection with the Gothic capitals. Like the two kinds of capitals, decorations can be pen-lettered or drawn-and-filled-in. Pen-lettered decorations look more harmonious and spontaneous with calligraphy — and if you use your pen this way you will gain expertise that will improve your control of the letters. Drawn-and-filled-in decorations, if carefully and expertly done, give you a chance to experiment with rich colors, textures, patterns, and gold.

If you want to use drawings to decorate your calligraphy, start a sketchbook of plants, animals, human figures, costumes, landscapes, and geometric designs — this will give you practice drawing and build up a sourcebook of design ideas.

Pen-lettered border

Drawn-and-filled-in border

Pen-lettered border

Drawn-and-filled-in border

Pen-lettered vs. drawn-and-filled-in decorations.

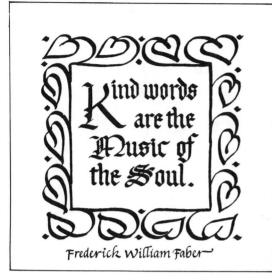

Shown above are two versions of the same design; one with pen-lettered decoration, the other with an equivalent drawn-and-filled-in decoration.

Here are two less sharply contrasted pieces of calligraphy; the pen-lettered version is softer and more informal than the drawn-and-filled-in version.

If you want to go further with Gothic capitals and decoration, your very best training will come from looking at facsimiles of medieval manuscripts. As you learned on page 14, in the chapter "Seeing Calligraphy," study these manuscripts on three levels; the layout, the craft, and the text.

GOTHIC CAPITALS: RECOMMENDED READING
The best book about technique is
<u>The Calligrapher's Handbook</u>, C.W. Lamb, ed. Faber & Faber.

bookhand

OW we must regress 500 years to trace the roots of a letter form that flowered in the Italian Renaissance. In 794 A.D., a minor renaissance, or rebirth, of interest in ancient Rome took place at the court of Charlemagne, who wanted to purify and justify his reign by invoking the spirit of the Roman Empire. In the process of reviving classical texts of philosophy and literature, he also revived the script in which they were written — a fourth-century Quadrata, many steps removed from the stone-carved capitals. Charlemagne's scribes (he himself wrote only with great difficulty) copied and modified this into a small letter that was eminently suited to bookwriting.

Thus, by modelling *their* new script on this revived Roman letter of Charlemagne, the scribes of the Renaissance improved a ninth-century version of a fourth-century interpretation of the classical Roman capitals. This alphabet, to be revived yet once more in the 19th century as Bookhand, exemplifies the strength and staying power of the Roman letter through the centuries.

Bookhand has much in common visually with Roman capitals. Many basic strokes are similar, a few letters are almost identical. and some family resemblances remain. One big change is the emergence of true ascenders and descenders.

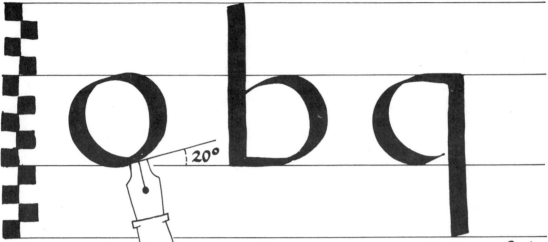

The Bookhand letter has three main parts: the letter body, the ascender, and the descender. The letter body is five pen widths tall; the ascenders and descenders extend four pen widths.

To combine Bookhand small letters with Roman capitals, recall the rule for proportion. Capitals are eight pen widths tall. Thus, capitals will be one pen width smaller than the height of letter body plus ascender.

Because Bookhand is the foundation for our most prevalent letter style today — Roman lower case type — your readers are going to be very familiar already with how it should look. This fact gives you much less latitude for inventiveness than the Celtic letter allows; Bookhand offers drastically fewer alternate forms. It is worth the effort, however, to master this simple, subtle, and disciplined style. Attention to two important details can make a big difference.

SERIFS: Two serif possibilities are shown above, starting with no serif, which is a perfectly fine and elegant solution to the problem. Be careful not to let the serif grow too heavy, or you will be on your way back in history to the Gothic letter.

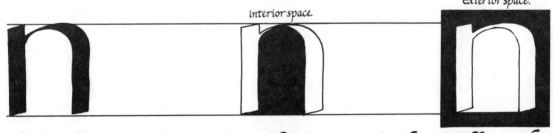

Interior space.

Exterior space.

WHITE SPACE: Because the letter is fairly small in relation to the pen width, the width of the pen stroke affects the shape of the white space. For example, the interior white space of the N above is symmetrical, while the exterior white space is asymmetrical. You will need to watch the white shapes delineated by both edges of the nib as you letter.

It is useful to begin your study of this alphabet by grouping together families of letters whose widths are the same.

o d p q b c e

The first group consists of round or half-round letters whose letter bodies are as wide as they are tall.

h u n r

The second group of letters has letter bodies that are 3/4 as wide as they are tall, and are open at top and bottom. K, V, X, Y, and Z also belong in this group.

t f s a g

T, F, S, A, and the top of G are 1/2 as wide as they are tall.

m w g ilj

M, W, and the descender of G are wider than they are tall, while the single-stroke letters make up the last of these groupings by letter body width.

Bookhand also shares the following characteristic with Gothic: certain letters can be studied in pairs because they are identical except for position.

q q b b

To illustrate, look at Q and B above. Rotate the page and look at them again upside down. B is now Q.

d p u n ſ f a t

D and P, U and N, and in some respects J and F, and A and T, have the same property of rotatability.

These paired letters help maintain the visual unity of a style while allowing for distinct legibility. First, they insure that any solution of a visual problem in one letter will also work visually with the other. For example, the

join of the curve and the straight stroke shown at left dictates how the same join should look on the paired letter. (To check, rotate the page.)

Second, this phenomenon of rotatability can generate alternate letters that are sure to harmonize.

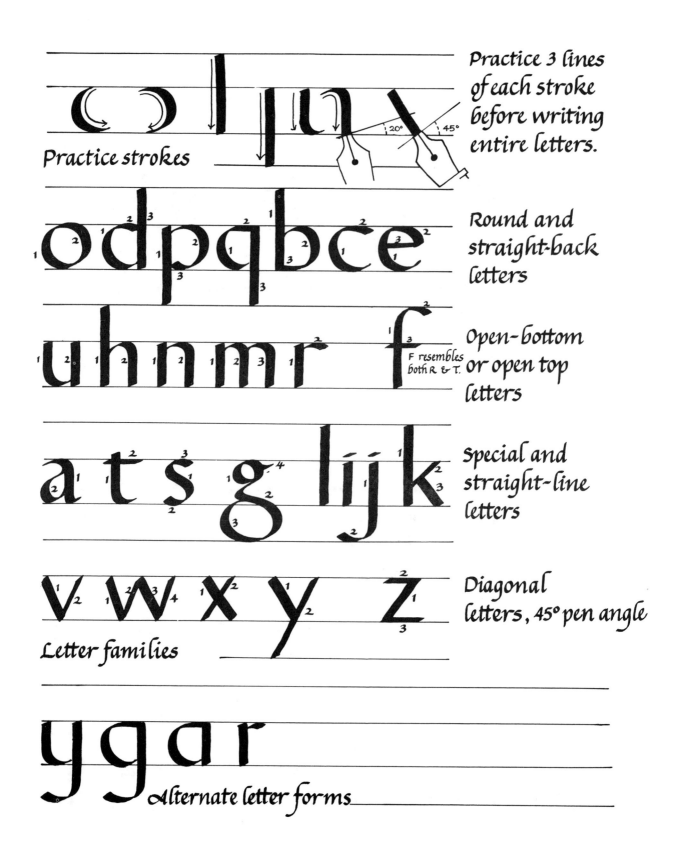

Practice strokes

Practice 3 lines of each stroke before writing entire letters.

Round and straight-back letters

Open-bottom or open top letters

F resembles both R & T.

Special and straight-line letters

Diagonal letters, 45° pen angle

Letter families

Alternate letter forms

this line for ascenders & descenders Pen angles

this line for capitals

20° 45°

Letter angle

Proportion

B4 B4

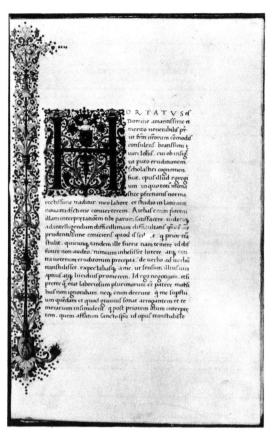

CHAPTER I

1 He that thinketh himself the goods maketh himself comic. 4 He that knoweth about rugs looketh foolish when he playeth the Victrola. 7 He that hath the dope on the music stuff is himself confounded when off his reservation.

MY son, on thy journeys wilt thou come upon many saying to themselves, Verily I am not like other men; I have good taste; I am of the elect.

2 At thine ideas will they say Pooh, Pooh; and when thou dost admire this or that will they say, Poor fish that thou art, laughing within the sleeves of their garments.

3 Unto each shall thou listen, laughing, if it please thee, in thine own sleeve; for it is written that he that would always know what is what must arise exceedingly early, yea, even before earliest cockcrow.

4 Upon my neighbor's floors are rugs of many colors. In the dark of the night, even as the day, could he choose between Mosul and Bokhara, between Tabriz, and Saruk, and Sara-

Raymond DaBoll

Two pages of Bookhand calligraphy — one five centuries old, the other one contemporary. In the page on the left, the Renaissance scribe has left generous amounts of white space between letters, words, and lines, and in the margins. The main visual impact comes from the grace of individual letters, the delicate, even texture on the page, and the pleasing proportions of text to white area; all non-letter decoration and color are concentrated in the capital and one margin. The modern page on the right shows an attractive irregularity of letter. The quote is humorous; it has been laid out and lettered in a masterfully deft, lighthearted, understated way.

Bookhand works beautifully for pieces of calligraphy where it is important for the reader to understand the text without effort. It is pleasant to read in long passages, and it has a lovely, subtle texture on the page. It suits quotes of lucid rationality, prose poetry, insightful meditation, and practical philosophy. It tones down rather than exaggerates a humorous quote. Leave abundant white space and don't put any decoration in it! Color and ornament should be concentrated and restrained.

Act in repose;
Be at rest when you work;
Relish unflavored things.
Great or small,
Frequent or rare,
Requite anger with virtue.
Take hard jobs in hand
While they are easy;
And great affairs too
While they are small.
The troubles of the world
Cannot be solved except
Before they grow too hard.
The business of the world
Cannot be done except
While relatively small.
The Wise Man, then, throughout his life,
Does nothing great and yet achieves
A greatness of his own.
Again, a promise lightly made
Inspires little confidence;
Or often trivial, sure that man
Will often come to grief.
Choosing hardship, then, the Wise Man
Never meets with hardship all his life.

Lao
Tzu

MS

A B C D E F
G H I K L M N
O P Q R S T V
X Y Y Z Z

Giamai tarde non
fur gratie diuine,
In quelle spero, che
in me ancor faráno
Alte operationi, e
pellegrine.

ARRIGHI

One last caution: don't insist upon a layout if it demands
too much stretching and squeezing to make the lines come
out the same length. Bookhand just doesn't lend itself to
the sort of elastic spacing you find in Celtic calligraphy.

Put all thine
eggs in one
basket and—
watch that basket.

Put all thine eggs
in one basket and—
watch that basket.
①

Put all thine
eggs in one
basket and --
watch that basket.
②

PUT ALL THINE EGGS
IN ONE BASKET AND
--watch that basket
Mark Twain
③

If you find yourself pencilling, erasing, and repencilling a
particular quote over and over to make it fit inside two straight
margins, you have several options: ① Change the margins and
try a longer line, ② redesign the page to allow for an uneven
right-hand margin, ③ choose a more obliging letter-style.
Some quotes have a mind of their own; don't distort them
to suit some preconceived idea you have. Be flexible.

BOOKHAND: RECOMMENDED READING
Edward Johnston, _Writing and Illuminating and Lettering_.
 The classic in the field, and a thorough look at Bookhand.

italic

talic letters flourished around the same time as Bookhand, in the early years of the Renaissance. This style represents a whole new concept in calligraphy — a style that is written not only by the monastic scribe and the professional copyist, but also by the law clerk, the scientist, the artist, the politician, the man of letters, and the scholar. For the first time in history the two major kinds of writing, the formal court style and the informal vernacular style, were fused into one shared style that could be written and read by a wide variety of people throughout the society. The Italian Renaissance was typified by the "Renaissance man" of diverse talents. Michelangelo, Petrarch, and the printer Aldus Manutius all had exemplary handwriting.

Italic letters got their name from an Italy that was quickly becoming the major cultural power in the post-medieval world. The model letters of writing masters were spread throughout educated Western Europe by the new medium of the printing press.

Italic handwriting was revived and popularized by calligraphers of the Arts and Crafts Movement of the 1890's, and is the spearhead of the calligraphy renaissance of the 1970's.

The Italic letter is built on two basic letter bodies, distinctly different from each other. Because this distinction is fundamental to the visual effect of Italic, you must be sure that you SEE it before you go on to try the letters.

① Use the same pen angle and letter body height as for Gothic; 45° and 5 pen widths high. Here are the first four basic strokes. Strokes 1 and 4 are about ⅔ as long as strokes 2 and 3.

② Connect the strokes. You will have to learn a new technique and break a previous rule. **PUSH** the pen from right to left for strokes 1 and 4. (Note: when you push with a very broad pen, you may have some trouble making the ink flow. Be prepared to pull those strokes when you do large Italic letters.)

③ Slant the rectangle about 5° away from vertical. You can visualize this slant as the wedge made by ½ pen width. Or think of it as 2 minutes after 12 o'clock.

④ Divide the rectangle diagonally, going **UP**.

⑤ Each half of the rectangle makes a basic triangular letter body — the 'a' triangle and the 'b' triangle. The order and direction of each stroke is important; don't lift the pen between the strokes.

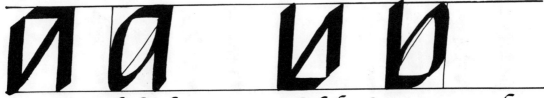

⑥ Add a vertical stroke to each triangle. (If you want to visualize it a different way, think of the 'a' form as the basic divided rectangle minus stroke 4 and the 'b' form as the basic divided rectangle minus stroke 1.

⑦ Round off the sharp corners slightly, but not too much, as you turn them.

How much rounding off is too much? This is crucial to the visual identity of the Italic letter, to distinguish it sharply from the rounded Bookhand.

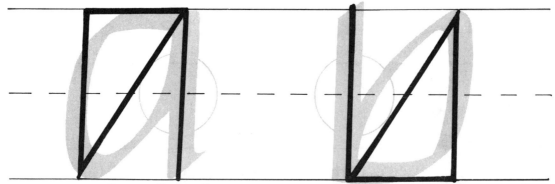

A good rule of thumb is to watch where the diagonal stroke leaves the upright stroke. It should grow out in a natural curve, separating from the main stroke about halfway up. Get this curve right and you will need only a slight rounding of the others.

un *Correct* un *Incorrect: too rounded*

With too much rounding off you lose the distinction between the 'a' and 'b' forms, the most important characteristic of the Italic style.

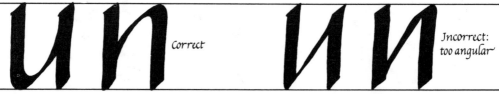

un *Correct* un *Incorrect: too angular*

Too much angularity makes the letter — and the whole page — harsh and ungraceful, and makes some letters look like each other.

There are two ways of ending strokes in the Italic alphabet: serif and swash.

First, include a small serif to begin or to end a stroke. ① Control this serif carefully. If it extends too far, ② your letters will overlap each other confusingly; if it turns too soon ③ or too sharply, it will look like a heavy-serifed Gothic letter. Note also that this serif does not belong on a vertical stroke ④ that is already joined by a diagonal stroke.

The second kind of stroke ending is an extra horizontal stroke on the left of a descender or the right of an ascender. These strokes are a rounded-off version of further rectangles added to the rectangular form of the basic letter body, constructed on a sort of grid.

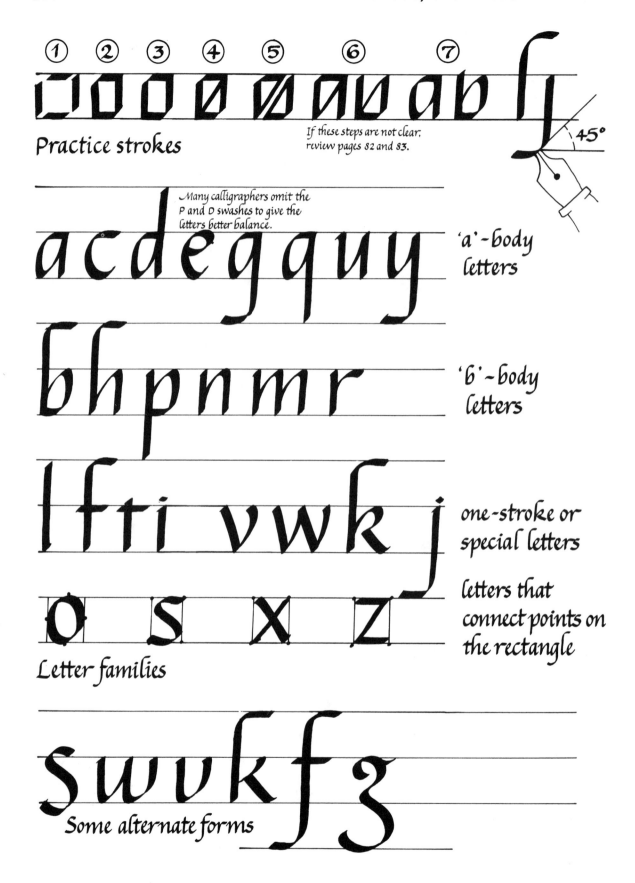

① ② ③ ④ ⑤ ⑥ ⑦

Practice strokes

If these steps are not clear, review pages 82 and 83.

45°

Many calligraphers omit the P and D swashes to give the letters better balance.

a c d e g g u y
'a'-body letters

b h p n m r
'b'-body letters

l f t i v w k j
one-stroke or special letters

o s x z
letters that connect points on the rectangle

Letter families

s w v k f z
Some alternate forms

Do not write directly on this sheet.
Lay a piece of paper over it so that
the guidelines show through faintly.

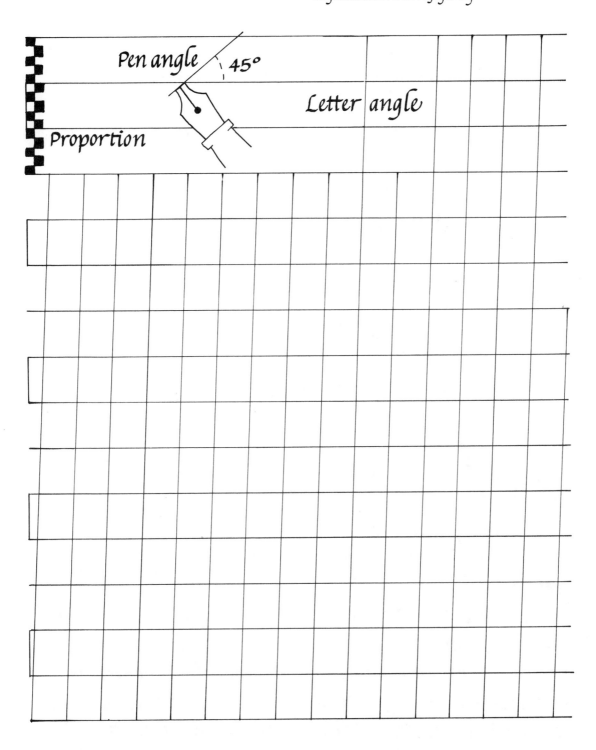

Pen angle 45°

Letter angle

Proportion

There are two approaches to letterspacing the Italic letter.
One is appropriate to larger, more formal, more carefully
executed letters; the other is appropriate to smaller, more
casual, more quickly executed letters. We will study them as
the Formal and Informal joins. Surprisingly, Informal
joins take longer to understand and learn.

un

In both cases the situation is the same; the scribe has com-
pleted one letter and is about to start the next. The pen is at
point A and must go to point B.

un co fte

In the Formal join, the scribe lifts the pen before moving it to
the next letter. In many cases, the scribe visually lines up the
end of the first letter with the beginning of the next. Thus there
is less space BETWEEN letters than there is INSIDE them.
For U and N above, this still does not really constitute a join;
but for some other letters this snug spacing allows projecting
strokes to overlap and appear joined. C can, with a little modi-
fication, join its neighbor at the bottom but not at the top. O
doesn't join at all. F and T, however, are very friendly, joining
other letters readily.

un un

Informal joins result when the scribe does not bother to lift the pen between the letters, or lifts it only part of the time.

minim

Informal joins carry the danger of ambiguity.

minim

To guard against this, you must develop a third curve — a **JOIN** curve, which is somewhere between the 'a'-body curve and the 'b'-body curve.

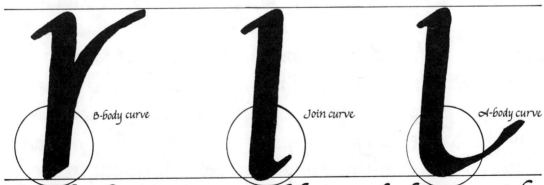

B-body curve Join curve A-body curve

This helps the reader distinguish between the letters and the joins.

When you approach the problem of Informal joins, bear a few mathematical realities in mind; since there are 26 letters, there will be 676 possible two-letter combinations. Reducing these 676 to a set of rules, and allowing latitude for an intelligent variation of personal styles, would take up this whole book! Instead, the calligrapher can make up a flexible set of rules based on a thorough understanding of the **PRINCIPLES** that govern joins.

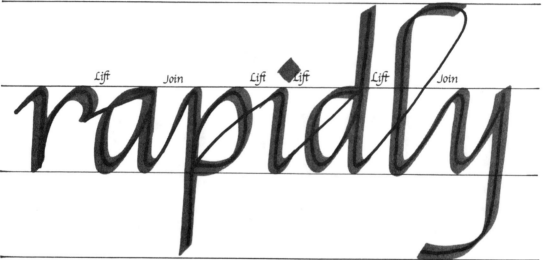

Calligraphy is motion. The solid line above shows the path of that motion. Calligraphy, however, is also ink. The shaded areas show where, in the path of motion, the scribe decided to bring the ink in contact with the paper. Thus, no matter whether your pen is touching the paper, your hand still makes the motion. This is how you decide which joins to make: look at the path of motion and see whether it enhances or detracts from the beauty and meaning of the letters. (Look at the possible joins above. Do you agree with the decisions that were made?)

To make your own style for Italic Informal joins, work through this exercise thoroughly and carefully.

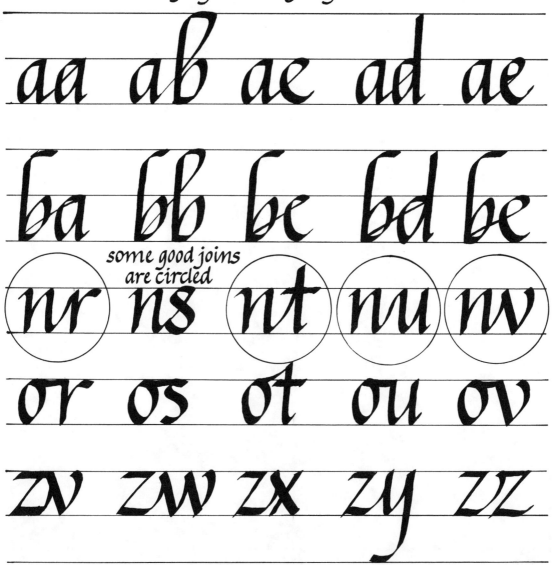

some good joins
are circled

Combine every letter of the alphabet with every other, keeping the pen in contact with the paper between each pair. Then look at this join; how much of it do you want to keep? (Don't be surprised to find yourself rejecting most of the 676 possible combinations.)

Anne
Bradstreet
1612–1672

Faithful daughter of Governor Thomas Dudley
Devoted wife to Governor Simon Bradstreet
Ancestress of many illustrious Americans.
"Mirror of her Age, Glory of her Sex."
Gentlewoman, Scholar, Publicist, Poet

With her, American
Poesy begins.
"Joined to the Church
at Boston."
1630

Italic letters are versatile. They adapt themselves to short prose passages, blank or rhymed poetry, long formal presentations, and informal everyday communications. They can be self-effacing—almost a background —; they do not intrude between the reader and the meaning of the words. The modern revival of Italics has made them visually familiar. In fact, for many people, 'Italic lettering' is synonymous with 'calligraphy.' This book itself is written out by hand in simple Italic calligraphy.

the GRAPHIC ARTS WORKSHOP

offers, from June 13 to July 15, studio facilities for work in typography, lithography, etching, calligraphy and wood engraving, as well as a seminar in the history of printing, book design and printmaking given by Professor Ray Nash at Broadbrook Mountain Farm, Royalton, Vt.

BooKS

IMPEDE THE PERSISTENCE OF STUPIDITY.

Society of Scribes BOX 933 NEW YORK CITY 10022

At the Danforth Museum, Framingham Contributions from the Western Suburbs Free admission (Closed Monday) Preview hours 1:00 4:30

The Channel 2 Art & Antique Preview May 1-9

margaret shepherd scribe

Having brilliant ideas is easy. Just have a lot of ideas— and throw most of them away.

Linus Pauling

MS

Do not write directly on this sheet.
Lay a piece of paper over it so that
the guidelines show through faintly.

A thorough knowledge of Italic with Informal joins will give you the basis for a lifetime of beautiful personal handwriting.

acdgquye bhpnmr

45°

lftij vwk oszx

ITALIC: RECOMMENDED READING

Alfred Fairbanks, The Story of Handwriting. Watson~Guptill.
Tom Gourdie, Italic Handwriting. Pentalic.

ITALIC CAPITALS 1500 A.D. - 2000 A.D.

ITH ITALIC CAPITALS WE COME FULL CIRCLE TO OUR ORIGINAL STUDY OF THE ROMAN CAPITALS. 1500 YEARS OF CHANGE AND STREAMLINING HAD PRODUCED FOUR DISTINCT MAJOR NEW ALPHABET STYLES: CELTIC, GOTHIC, ITALIC, AND BOOKHAND. NOW, WITH THE ITALIAN RENAISSANCE IN CLASSICAL CULTURE, THE ORIGINAL ROMAN CAPITALS— VISIBLE EVERYWHERE ON RUINED BUILDINGS AND MONUMENTS— FINALLY ENJOYED AN AUTHENTIC REVIVAL. THEY WERE METICULOUSLY COPIED AND DISSECTED, AND THEN INTEGRATED INTO LETTER AND TYPE DESIGNS FOR THE LOWER CASE ROMAN BOOKHAND.

ALMOST AS AN AFTERTHOUGHT, THESE ROMAN CAPITALS WERE ADDED TO THE ITALIC SMALL LETTERS, WITH SOME SMALL BUT FUNDAMENTAL DESIGN CHANGES AND A FEW SUBSTITUTED FORMS FROM CELTIC AND ITALIC ALPHABETS.

20th CENTURY CALLIGRAPHERS PIONEERED THE USE OF SIMPLIFIED ITALIC CAPITALS AS A TEXT LETTER RATHER THAN JUST AS AN ADJUNCT TO THE SMALL LETTER— THUS GIVING THE ROMAN LETTER ONE MORE NEW LEASE ON LIFE.

Italic capitals are about seven pen widths high; they lean at an angle equal to the Italic small letters (5° off vertical); and the pen angle is 45°. Most of the Italic capitals can be derived from the Roman capital letter families through the following steps:

O B I N

① Start with the Roman capital. If it is a wide letter make it narrower, if it is a narrow letter make it wider, until all of the letters are around ¾ as wide as they are tall. The extremely wide letters like M and W, and the extremely narrow ones like I and J, will of course be a little wider or narrower than this ¾ proportion. Letters that were already ¾ as wide as their height like N and H will remain the same width.

O B I N

② Change the pen angle to around 45° Now all letters that formerly required a change in pen angle are written without such a change; horizontal and vertical strokes will be the same thickness.

O B I N

③ Slant the letter. Verticals should be 5° off vertical. Rounded letters should be envisioned as inhabiting a slanted rectangle.

O B I N

B I N

④ You can add the small entry and exit serifs if you wish. Just be sure that the serifs on horizontal and vertical strokes overlap **PERFECTLY** when these main strokes join each other.

These rules will give you a strong, simple, readable, and very practical basic alphabet of Italic capitals that look good on their own and harmonize with the Italic small letter. In both functions they preserve some of the dignity and spirit of the Roman letter.

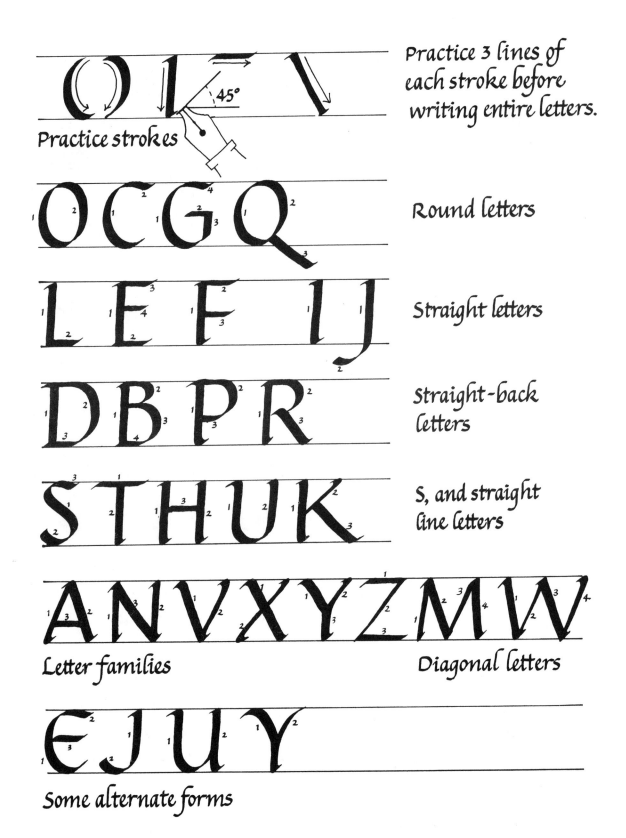

Practice 3 lines of each stroke before writing entire letters.

Practice strokes

Round letters

Straight letters

Straight-back letters

S, and straight line letters

Letter families

Diagonal letters

Some alternate forms

Pen angle 45°

B4

Letter angle

Do not write directly on this sheet.
Lay a piece of paper over it so that
the guidelines show through faintly.

Proportion

The basic Italic capital can be elaborated with a decorative stroke called a **SWASH**. A swash can be either an **EXTENSION** of an existing stroke or a completely separate stroke **ADDED ON** to the whole letter structure.

This letter has extension swashes.

This letter has added-on swashes. (The extension swash of the the R-tail becomes added-on when it crosses over itself.)

With Italic swash capitals you can give your pen free rein. There is no one set of prescribed, official swash capitals to memorize — only a rationale for coordinating the visual effect of capitals that appear on the same page, so that they harmonize with each other.

BREAD

One good rule of thumb is to stick with either extension or added-on swashes; this helps you give letters in the same family the same treatment. In the line above, the swash on D is different from the treatment of the other straight-back letters.

Give us
this day
our daily
bread.

Give us
this day
our daily
BREAD.

GIVE US
THIS DAY
OUR DAILY
BREAD.

Like Gothic capitals, Italic swash capitals do not enjoy each other's company. Limit the number of swashes per page to two or three; more, and your calligraphy will look like someone wearing too much jewelry. Similarly, anything in ALL CAPITALS looks better without swashes: ALL CAPITALS.

Swash capitals by Giouanniantonio Tagliente, 16th century
writing master. From Three Classics of Italian Calligraphy. Dover.

Italic capitals offer the calligrapher many possibilities. The basic capitals are just beginning to emerge, in the 20th century, as a separate alphabet in their own right. They are remarkably adaptable to uneven line spacing and to wild variation of size from letter to letter; at the same time, however, they can conform gracefully to traditional quotes, conventional layout, and uniform line treatment.

Swash capitals are useful in themselves or as the starting-point for swashes without letters — swashes as abstract pen decoration. They make beautiful monograms, letterheads, book titles, and labels.

WHY SHOULD I FEEL LONELY? IS NOT OUR PLANET IN THE MILKY WAY?

MS Thoreau

Monday's child is fair of face

Tuesday's Child is full of Grace

Wednesday's child is full of woe

thursday's child has far to go

Friday's child is Loving & giving

Saturday's child works hard for a living

But the child that is born
on the Sabbath day
is bonny & blithe & good & gay

MS

Pastiques

At: Golden Past Gallery
Rt. 28, So. Wolfeboro, N.H.

MS

David R. Godine

The Barclay

LIFE
is too short
to be small.

Benjamin Disraeli

Life
IS TOO SHORT
TO BE SMALL.

Benjamin Disraeli

When you combine two or three letter styles (please; not more than three) you can use as a guideline the general rule, **HIERARCHY OF SCRIPTS.** This simply means that the historically oldest script comes first on the page. Thus the first example, above, is preferable to the second, since Roman is an older style than Italic.

ITALIC CAPITALS: RECOMMENDED READING

Tom Gourdie, _Italic Lettering_. Penguin.
Oscar Ogg, editor. _Three Classics of Italian Calligraphy_. Dover.

NUMERALS & SYMBOLS 1200 A.D.

eginning with the Crusades and increasing throughout the late Middle Ages as power shifted to the Mediterranean, a new element entered the art and culture of Europe — Arabic. Our numerals and our punctuation originated in the flowing forms of Middle East brush calligraphy.

Another legacy of this period is the ligature, the scribes' habit of joining or abbreviating common letter groups to make a new symbol. Some, like the ampersand (&), are given honorary membership in the alphabet.

Numerals come in two versions, depending on whether you use them with all-capitals or capital-and-small letters. The forms are almost identical in both versions; they change only their relation to the guide lines.

1 2 3 4 5

6 7 8 9 0

The **CAPITAL** numerals are contained within top and bottom lines.

3 5 2 7

Notice the similarities between pairs of numerals. 3 and 5 differ only by one stroke. 2 and 7 are rotated forms of each other—halfway up. And, of course, 6 and 9 are exact rotated forms of each other.

1 2 3 4 5
6 7 8 9 0

The small~letter numerals have ascenders and descenders.
Many 'alphabets' of these numerals place the odd numbers
below the line and the even ones above. This rule, however,
is flexible for 1, 2, 4, and 0.

1 7 1 7

A note of caution. Europeans cross their **SEVENS**, not primar-
ily as decoration but to distinguish them from their **ONES**. You
don't need to cross 7 unless you add the long upstroke on **1**.

The symbols here are proportioned to fit Bookhand; they can be modified by using the guideline sheet for any other letter style.

1 2 3 4 5 6 7 8 9 0

& %

? ! . : , " — " –

£ ¢ $ #

Symbol families

Some alternate forms

Do not write directly on this sheet.
Lay a piece of paper over it so that
the guidelines show through faintly.

LIGATURES are hybrids; a collection of forms made by abbreviations, joins, latinization, archaic survivals, and borrowed symbols — and combinations of any of these.

et et & &

The **AMPERSAND** is a case in point. It started life as "et," the Latin word for "and." Since "and" occurs frequently, scribes ran the letters together to speed things up and to save space. And long after local languages had superseded Latin, this stylized "et" survived as the abstract "&" symbol.

Other ligatures are being born all the time. £ represents pounds — first as an abbreviation for French livres, now a designation for British money. ¢ for a penny is confusing to non-Americans until they understand the derivation; cent = one hundredth. Even $ can be explained as a ligature of U superimposed onto S. And an enterprising type designer has proposed a new symbol for that traditional expression of befuddlement and chagrin !? — the interobang ‽ Calligraphers find that ligatures almost make themselves; as you saw in the section on Italic joins, certain letters combine very readily. Start with the obvious ones like ff, tt, and ft; you will discover others as you letter long passages and polish your own individual style under the pressure of repetition.

Punctuation marks, like numerals, have a somewhat in-
dependent relationship to the guidelines. If you learn the
basic forms you can realign them to suit any alphabet.

If you execute the quotation marks accurately, you will
discover that you need two different sets of them — one pair
shaped like 6's for the beginning of the quoted passage and
another pair shaped like 9's for the end.
Punctuation marks and numerals, without a doubt, present the
calligrapher with an interesting problem. The 26 letters of
the alphabet evolved slowly and organically over centuries of
constant use, handed from scribe to scribe until they were worn
smooth. Punctuation and numerals, on the other hand, were
added on so late in the alphabet's development that they hardly
had a chance to be westernized and integrated into the letters
before the invention of moveable type froze their growth. They
were penlettered for a so much shorter time than they were type-
designed that the modern calligrapher is still faced with the
challenge of domesticating these exotic imports— reconciling
them to the demands of top and bottom guidelines and the
broad-edge pen.

Now you have the basic skills to continue learning calligraphy on your own. Remember that, while you should learn from the letters of other scribes throughout history, calligraphy is a growing, changing, contemporary visual art; your calligraphy should reflect the arts of the 20th century and not try to mimic the spirit of an earlier age. It will thoroughly repay the effort you put into being original. Work and practice to discipline your hand; compare and communicate with other calligraphers to stimulate your intellect; and everywhere, all the time, use your eyes.

FURTHER STUDY: RECOMMENDED READING

Arthur Baker, Calligraphy. Dover.
 Highly recommended; original and contemporary.
Nicolette Gray, Lettering as Drawing. 2 volumes: The Moving Line and Contour and Silhouette. Oxford Paperbacks.
Ben Shahn, Love and Joy About Letters. Grossman.
Jacquelin Svaren, Written Letters: 22 Alphabets. Bond-Wheelwright.

there are books in which
the footnotes or the comments
scrawled by some reader's
hand in the margin, are more
interesting than the text.
the world is one of these books.
SANTAYANA

114.

Appendix

Glossary
Lefthanders

GLOSSARY

Page

81 ALDUS MANUTIUS — *Renaissance printer and type designer, who designed and cut the first Italic typeface.*

34 ASCENDER — *The part of a letter that extends above the main letter body.*

47 AXIS OF SYMMETRY — *The center line between two identical halves.*

Axis of symmetry

6 BARREL — *Part of a pen; the body.*

CALLIGRAPHY — *From the Greek words for 'beautiful' and 'writing.'*

7 CAPILLARY ACTION — *Process by which a liquid travels between two nearly-touching surfaces.*

71 CHARLEMAGNE — *French king, 742-814 A.D., under whose rule scholarship in classical language, literature, and art was reawakened.*

9 COLD-PRESS — *also HOT-PRESS—Two paper-finishing processes, the first of which leaves the paper slightly rough and textured, the second of which gives it a hard, smooth surface.*

34 DESCENDER — *The part of a letter that extends below the main letter body.*

68 DRAWN-AND-FILLED-IN — *Outlined with a thin line and filled in with solid color or pattern.*

70 FACSIMILE — *Photographic or printed reproduction of a manuscript.*

18 FLUSH — *Lined up along a straight vertical margin.*

64 FOLIATED — *Decorated with leaves, vines, and flowers.*

64 ILLUMINATED — *Decorated with gold leaf or gold paint. Can also be used in the broader sense to mean decorated with any kind of non-letter ornament.*

64 INHABITED — *Decorated with abstract or naturalistic birds and beasts inside a capital.*

64 HISTORIATED — *decorated with a scene depicting a specific event.*

9 HOT-PRESS — *see COLD-PRESS.*

88 JOIN — *Informal and Formal — Two ways of connecting letters: the first, by not raising the pen between letters, the second, by raising the pen and positioning the letters so that they just meet.*

Join Informal *Join Formal*

17 LAYOUT — *The overall design of a page.*

12 LETTER ANGLE — *The angle made by the upright straight stroke of the letter and a 90° true vertical line.*

34 LETTER BODY — *The main part of a letter, often rounded or closed.*

LETTER FAMILIES — *Calligraphy groupings of letters that share similar characteristics. May be classified on the basis of width, basic shape, ascenders and descenders, number of strokes, etc.*

110 LIGATURE — *A stylized habitual joining of letters that occur together frequently.*

16 LINEAR DISTANCE — *A one-dimensional measurement.*

6 NIB — *Part of a pen; the part that draws ink from the reservoir to the point.*

45 PARCHMENT — *Writing surface made of sheep skin.*

90 PATH OF MOTION — *The imaginary line that represents the motion of the scribe's pen over the paper.*

12, 22 PEN ANGLE — *The angle made by the flat end of the pen and the horizontal guideline.*

68 PEN-LETTERED — *Written or ornamented with a broad pen.*

19 PHOENICIANS — *Commercial trading Mediterranean people, who spread many ideas from city to city. 2000 B.C.*

6 POINT — *Part of a pen; the part that touches the paper.*

16, 17 POSITIVE SPACE — *also NEGATIVE SPACE — The shapes made by the ink on a page, and the white shapes in and around the ink shapes.*

20 PROPORTION — *Ratio between parts of a letter.*

18 RAGGED — *uneven.*

71 RENAISSANCE — *The 15th century rebirth of interest in classical culture; any revival.*

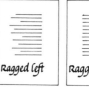

Ragged left *Ragged right*

6 RESERVOIR — *Part of a pen; the ink container.*

75 ROTATABILITY — *The relationship between letters where one looks like an upside-down version of the other.*

64 RUBRICATED — *Colored in red.*

44 RUNES — *Straight-line letters indigenous to Northern Europe.*

28 SERIF — *An extra line that marks the end of a pen stroke.*

42 SPACING — *STANDARD, TIGHT, and OVERLAPPING — Letterspacing of closer and closer distance between letters.*

85 SWASH — *A separate, decorative pen stroke added to the basic form of the letter.*

45 TEXTURE — *The overall pattern of the lettered area of a page.*

26 TRAJAN INSCRIPTION — *The 113 A.D. Roman inscription that is used as a model for beautifully proportioned capitals.*

The naming of calligraphic letter styles does not follow any hard and fast system. You may already know the major historical alphabets by different names from those given here; some of the most common equivalents are listed below.

ROMAN Trajan, Capitals
 also Quadrata, Rustica

CELTIC Uncial, Half-uncial, Irish, Insular

GOTHIC Black letter, Grotesque, Old English, Fraktur.
 also Rotunda, Batarde, Textura

GOTHIC CAPITALS Lombardic, Majuscules, Versals

BOOKHAND Roman lower case, Foundational hand,
 Humanistica
 also Carolingian minuscule

ITALIC Chancery, Current, Cursive, Chancellaresca

ITALIC CAPITALS Swash capitals

If you are lefthanded, traditional calligraphy will be challeng-
ing but not impossible. You will need to turn your hand and
rotate the paper, and perhaps use a special pen nib for left-
handers, to achieve the pen angles required for each alphabet.
First, keep your left elbow as close to your body as you comfortably
can. Second, turn the paper to make the proper pen angle. Third,
if necessary, use a left-hand pen nib. (a. or b. below.)

 a. b. **c.**

Right hand stroke direction Left hand stroke direction

If you normally write with your arm curled all the way
around, you will find it easier to keep the correct pen angle;
remember, however, that in some alphabets you will have
to reverse the direction of the stroke.

You will find that the spiral binding of this book gets in your
way when you use the guideline sheets. They are set up for
righthanders. Therefore, two extra sheets are provided here
for you to cut out and use as guideline sheets separate from the
binding. The first one is proportioned for Roman, Gothic,
and Italic capitals; the second is for Celtic, Gothic, and Italic
letters. You can trace the Bookhand yourself on page 77, and
use the Italic handwriting on page 94 as is.

In general, of course, substitute "right" for "left" and vice versa;
and take care, as you letter from left to right, not to let your
left hand trail through the ink and smear it.

Roman pen angle 20°

Gothic & Italic pen angle 45°

Roman & Gothic
letter angle

Italic
letter
angle

B4

B4

Proportion

Do not write directly on this sheet. **LEFTHANDERS / GUIDELINE SHEET**
Lay a piece of paper over it so that
the guidelines show through faintly.

Gothic & Italic
pen angle

Celtic pen angle 15° 45°

Celtic | & Gothic
Letter | angle Italic | letter angle

Proportion